LANDSCAPE

PHOTOGRAPHY

THE ESSENTIAL BEGINNER'S GUIDE

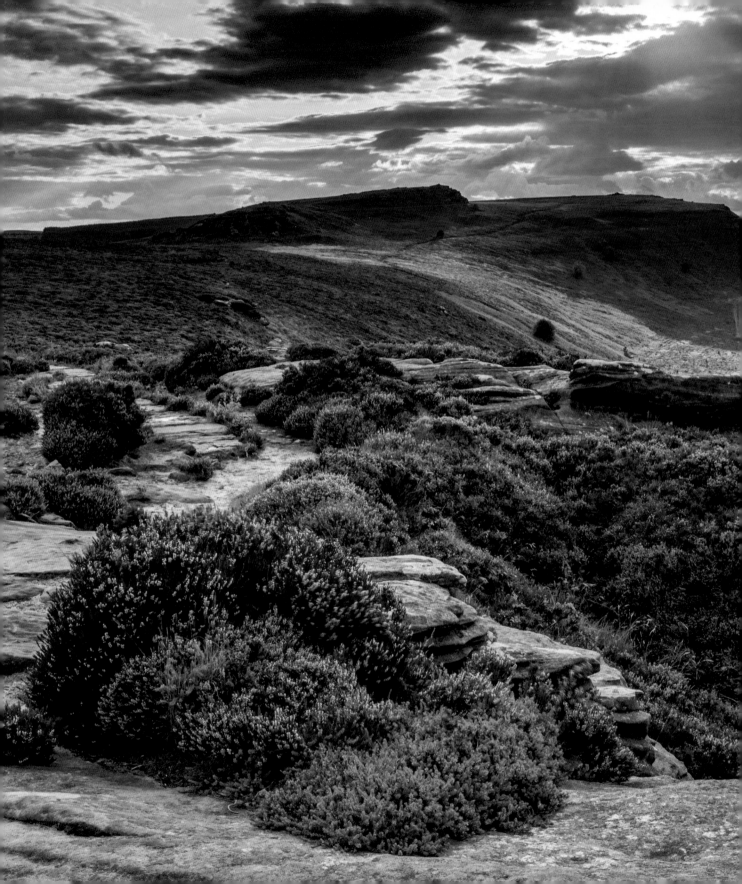

CONTENTS

PART ONE
GETTING STARTED

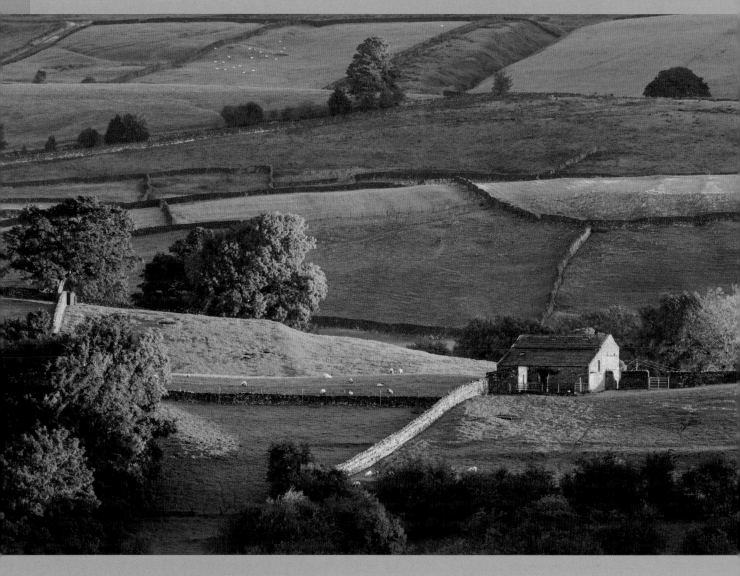

No one is born a photographer. All photographers—no matter how successful they later become—start off not knowing anything about photography.

The principles of photography may seem impenetrable initially, but there is a logic to them that can be absorbed with practice and a willingness to learn. Part One of this book covers those principles, concentrating on how they relate to landscape photography. However, if you feel you already have a reasonable grasp of the basics, you can jump to Part Two to begin applying that knowledge, before expanding your understanding in Part Three.

Wherever you choose to begin, welcome to the wonderful world of landscape photography—I hope you enjoy your visit and decide to stick around!

David Taylor

Left: This is a "traditional" landscape photograph, albeit with constructed elements, as well as natural ones. It's horizontal in orientation, which is often referred to as "landscape format," but for the sake of clarity, orientation will only be referred to in terms of "horizontal" or "vertical" throughout this book.

CHOOSING A CAMERA

The minimum equipment you will need to shoot a landscape photograph is a camera, a lens, and some way to store your photos as they're exposed (which could be a memory card, cloud storage via Wi-Fi, or even a roll of film).

SYSTEM CAMERAS

Although there are many highly capable compact cameras available, and they are improving all the time, a system camera is recommended for landscape photography. A system camera is a camera that is just one component in a more expansive image-making system (hence the name). Other components include lenses, flash units, and accessories such as remote releases and supplementary battery packs/grips.

Compared to a compact camera, this potentially makes a system camera far more expensive in the long term, as system cameras are never "complete" (it would be impossible to own every available lens or accessory). However, this is a big advantage, because as your confidence and skill levels grow you can expand the capabilities of your camera to keep pace. Because a system camera is essentially just one component in the system, you can even replace your camera, but still keep your favorite lenses (unless you decide to switch brands;

system cameras may be modular, but that doesn't apply across brands).

There are now two types of system cameras: DSLRs and mirrorless cameras (also known as CSCs or Compact System Cameras). DSLR stands for Digital Single Lens Reflex, which refers to a reflex mirror inside the camera that redirects light from the lens up through a pentaprism to an optical viewfinder (OVF). When an exposure is made, the reflex mirror swings out of the way to reveal the camera shutter behind it. The shutter then opens to allow light to fall onto the sensor, making an exposure. When the exposure is complete, the shutter closes and the mirror swings back into place.

COMPACT SYSTEM CAMERAS

Compact system cameras (CSCs) don't use a reflex mirror. Instead, the sensor feeds a "live" image directly to the rear LCD screen or electronic viewfinder (EVF).

Both systems—DSLR and mirrorless—have advantages and disadvantages. Mirrorless cameras tend to have slower autofocus systems than DSLRs, for example, although the difference is marginal and getting smaller (and it could be argued it's irrelevant for landscape photography). Electronic viewfinders also aren't yet as good in low light as an optical

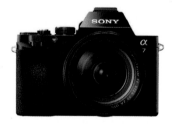

Above: As the name suggests, compact, or "point-and-shoot" digital cameras are small in size and therefore very portable. However, the vast majority do not deliver the same image quality as a system camera, so a DSLR camera or CSC is a better option for landscape photography. Image © Nikon.

Above: Sony's A7 CSC is a small, light mirrorless full-frame camera. This type of camerai is ideal if the aim is to keep the weight of your camera bag down.
Image © Sony.

viewfinder, although again, this technology improves year on year.

Canon, Nikon, and Pentax are the brands most closely associated with DLSR cameras, while Fujifilm, Olympus, Panasonic, and Sony are leading manufacturers of mirrorless cameras.

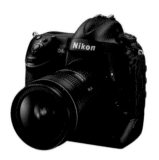

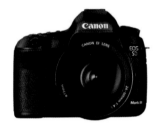

Above: Canon's professional EOS 5D Mk III DSLR is significantly larger and heavier than the Sony A7 (left), yet both feature a full-frame sensor. Image © Canon.

Above: Professional-level DSLR cameras don't look hugely different to enthusiast models, but they typically have a higher build quality (which means they can withstand a few bumps or raindrops), larger sensors (which enable better low-light photography), and additional features, such as the ability to take more shots per second. Image © Nikon.

Below: A particularly useful attribute for a landscape photographer's camera is weather sealing. Although this doesn't make the camera completely waterproof, it will protect it from light rain or water spray. However, even with weather sealing you need to be careful around salt water—it is corrosive and should be cleaned off your camera as soon as possible.

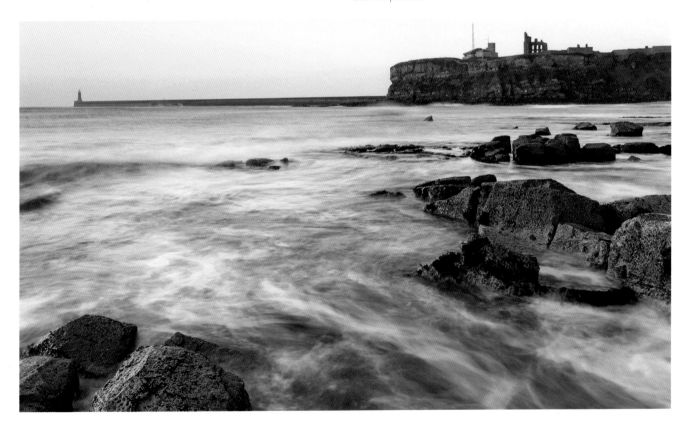

SENSOR SIZE

Inside every digital camera is an image-making sensor. These don't all come in one size—in fact, there is a wide range of sensors used by camera manufacturers, from those that are no bigger than a fingernail to substantially larger 54 x 40mm medium-format sensors. However, the three most common sizes used in system cameras are (in ascending order of size): Micro Fours Thirds (17.3 x 13mm), APS-C/cropped (23.7 x 15.6mm), and full-frame/35mm (36 x 24mm).

There are advantages and disadvantages to each of these three size sensors. Using a smaller sensor means that a camera system can be made smaller and lighter (which is no bad thing for a landscape photographer), but the individual photodiodes on the sensor are smaller too. Photodiodes are tiny "buckets" on a sensor that collect light during an exposure. The larger the "bucket" is, the more light it can gather and the more information the camera will have to create the final image. Smaller sensors typically suffer from a reduced dynamic range (see page 35) and greater noise at a given ISO setting (see page 32) than a larger sensor. This means that it's often more necessary to use filters (such as ND graduate filters—see page 20) or a tripod when using a small-sensor camera .

So, why don't we all simply use cameras with large sensors? The answer to this is partly to do with cost (larger sensors are more expensive to manufacture, so the cameras cost more), but the camera bodies and lenses also have to be physically larger and therefore heavier. As with most decisions about photography equipment, there's a trade-off between cost, convenience, and personal needs.

RELATIVE SENSOR SIZES

The images below show the relative sensor sizes of the three most common system camera formats:

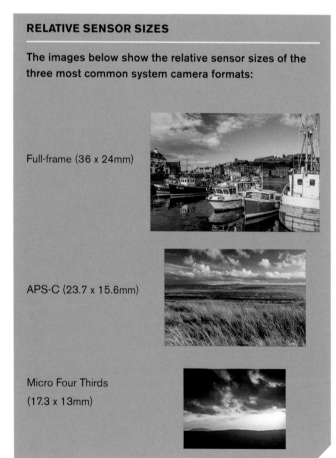

Full-frame (36 x 24mm)

APS-C (23.7 x 15.6mm)

Micro Four Thirds
(17.3 x 13mm)

Above: The full-frame sensor used in Nikon's Df DSLR camera.
Image © Nikon.

LENSES

Ultimately, no matter how wonderful your camera is, your images will only be as good as the lens you use. A lot of cameras come with a "kit" zoom lens. Although these are generally decent lenses, they are never the best lens in a camera system's line-up. Most photographers will eventually add one or two more lenses to their kit bag to allow them to expand the range and type of images they can shoot.

FOCAL LENGTH

The most important attribute of a lens is its focal length. There are two basic types of lens: prime lenses (which have a fixed focal length) and zoom lenses (which cover a variable range of focal lengths). Put scientifically, focal length is a measurement of the distance (in millimeters) from the optical center of the lens to the focal plane when a subject at infinity is in focus. Although this may not mean much (and there's no reason why it should!), it is useful to understand that the shorter the focal length of a lens, the wider the angle (or field) of view projected onto the sensor will be. This means that more of a scene can be included in the final image. The longer the focal length, the more an image is magnified, at the expense of the angle of view.

Unfortunately, this is complicated by the size of the sensor, which also has an effect on the angle of view

captured by a lens. The smaller the sensor, the smaller the angle of view at a particular focal length. A good example of this effect can be seen with a 24mm lens. On a full-frame camera this is now regarded as a standard wide-angle lens, with an angle of view of 84°. However, fit this lens to a camera with an APS-C-sized sensor (which is smaller than full-frame) and the angle of view is reduced to 61°. Therefore, to match a 24mm angle of view on an APS-C camera you would need to use a 16mm focal length instead.

Below: This image was shot using a full-frame camera and a 24mm lens. If the same lens had been used on a camera with an APS-C-sized sensor, the angle of view would have been reduced to the green box. On a Micro Four Thirds camera, the angle of view would have been smaller still, reduced to the inner blue box.

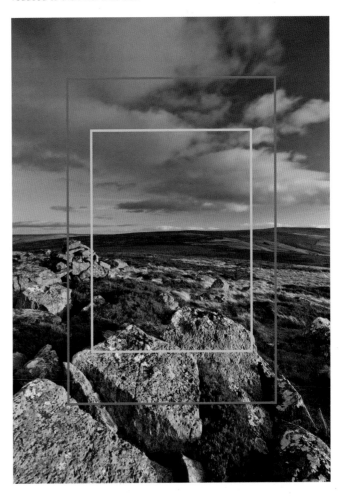

> **NOTES**
>
> - Angle of view generally refers to the diagonal measurement, unless stated otherwise.
>
> - Lens manufacturers often describe lenses as having a "full-frame/35mm equivalent" focal length. This only refers to the angle of view.
>
> - Focal length also affects depth of field at a given aperture, but this isn't altered by the size of the sensor. See page 29 for more information about depth of field.

PRIMES OR ZOOM?

There's no denying that it's more convenient to have one or two zoom lenses that cover a wide range of focal lengths, rather than a larger number of prime lenses. As an example, to match a 24–85mm zoom lens you would probably need a set of at least four prime lenses: 24mm, 35mm, 50mm, and 85mm. This combination would be heavier than a single zoom and wouldn't include any in between focal lengths (such as 60mm, for example), so you would run the risk that you had the wrong lens fitted to the camera at the wrong moment. It could also be more expensive to buy four prime lenses than a single zoom.

Where prime lenses have the advantage is in image quality and maximum aperture. There are few truly awful zoom lenses being manufactured today, but prime lenses still tend to outshine zooms when it comes to factors such as sharpness and distortion (see page 15).

Prime lenses also usually have larger maximum apertures than zooms. A large maximum aperture will mean the viewfinder is brighter and easier to look through, and a Live View image will be slightly less grainy. This can make a considerable difference to how easy it is to compose an image when working in low light.

Large maximum apertures also make it easier for a camera to autofocus in low light (or for you to focus manually), so it is worth considering buying a prime lens or two, even if you don't want to abandon your zooms entirely.

Below: This was shot with a 35mm prime lens. When using a prime lens you start to "see" potential shots more easily once you've tuned into the lens' angle of view.

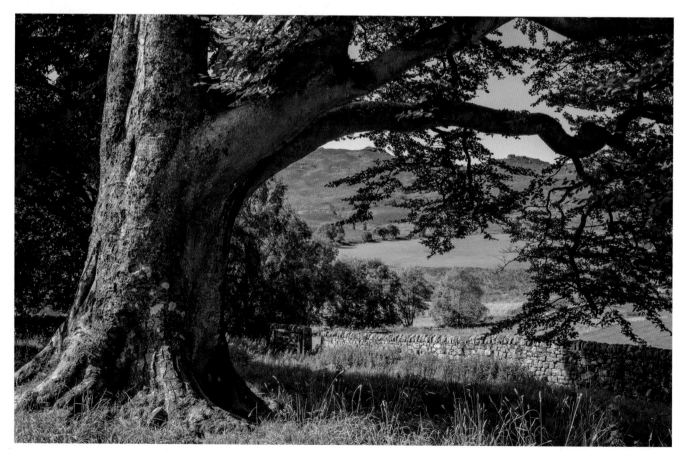

WIDE-ANGLE LENSES

A wide-angle lens takes in a wide-angle of view (hence the name), making it the type of lens most suited to landscape photography. Wide-angle lenses allow you to capture greater swathes of a scene than the standard and telephoto lenses described on the following page.

The widest wide-angle lens is a type known as a "fisheye" lens, which has a very short focal length. Fisheye lenses have a 180° angle of view—essentially from one side of the camera to the other. They're called "fisheyes" because images shot with these lenses are highly distorted. Consequently, they have a very limited use and aren't really suitable for general landscape photography.

A more useful focal length on a full-frame camera is 24mm, which equates to 16mm on an APS-C camera, or 12mm on a Micro Four Thirds camera. This has almost become the default wide-angle focal length, with many standard zooms now starting at this setting.

A visual quirk of wide-angle lenses is that the spatial relationships of elements in a scene are exaggerated. The background in a wide-angle lens image will appear smaller and further away than it is in reality. Consequently, it is all too easy to create empty-looking images with a wide-angle lens. The key to success is to think very carefully about your foreground—you will often need to get in close and fill the foreground of the image with your subject.

NOTE

- Wide-angle lenses have inherently greater depth of field at a given aperture than standard or telephoto lenses. See page 29 for more information about depth of field.

Below: Filling the foreground by getting in close to your subject is one of the easiest ways to give wide-angle shots impact.

STANDARD LENSES

A standard lens is one with a focal length that is the same size as the diagonal measurement of the camera's sensor. This means that the focal length of a standard lens is different, depending on whether you're shooting with a full-frame, APS-C, or Micro Four Thirds camera. The standard focal length for these three camera systems is 50mm, 28mm, and 24mm respectively (these focal lengths are usually available as prime lenses, although a zoom lens set at the same focal length could be regarded temporarily as a standard lens).

There's a good reason why standard lenses fall into a category of their own: they produce natural-looking images that closely match the way we see the world. However, because of this normality, they are also unjustly overlooked—they are not as extreme as a wide-angle or telephoto lens. Yet for a more "documentary" approach to landscape photography a standard lens is ideal.

TELEPHOTO LENSES

A simple definition of a telephoto lens is one that has a longer focal length than a standard lens. Telephoto lenses magnify the image projected onto the sensor, making the subject appear larger in the frame. This makes them perfect for wildlife subjects or for shooting close-ups of subjects in the landscape.

The drawbacks to telephoto lenses are that the angle of view is restricted and depth of field is less at a given aperture than a wide-angle or standard lens. The longer the focal length of the lens, the greater the magnification and reduction in both angle of view and depth of field.

Below: Images shot with a standard lens may not have the immediate impact of a shot taken with a wide-angle lens (or a telephoto), but I like using a standard lens precisely because of its unfussy nature.

COMMON LENS PROBLEMS

There's no such thing as a "perfect" lens. Lens manufacturers need to strike a balance between size, weight, cost, and complexity. As a result, there are three main problems that are seen to varying degrees in a lens: vignetting, distortion, and chromatic aberration. The good news is that they can generally be corrected in-camera or during postproduction.

Vignetting is seen as a darkening of the corners of an image relative to the center. It's most noticeable when a lens is used at maximum aperture, reducing in effect as the aperture is made smaller. This means that vignetting isn't a problem that affects landscape photographers too much, as small apertures are often used to increase depth of field.

Lens distortion causes what should be a straight line in an image to bend. There are two types of distortion: barrel distortion and pincushion distortion. Barrel distortion causes the bending to bow out toward the edge of the frame, while pincushion distortion causes the bending to bow in toward the center of the frame. Zoom lenses often display barrel distortion at the wide-angle end of the focal length range and pincushion distortion at the telephoto end. Again, distortion is something that landscape photographers may not notice: there are very few perfectly straight lines in nature, with the exception of watery horizons.

Chromatic aberration is seen as purple/green or red/cyan "fringing" around high contrast edges in an image (it is often seen around the edges of tree branches against a bright sky). Chromatic aberration is caused by the inability of lens to focus the various wavelengths of visible light to the same point. Modern lenses are better at suppressing chromatic aberration than older lenses, but it can still be a problem. Thankfully, it's relatively easy to fix and it may not even be present in many images (especially those that are low in contrast).

Below: This image suffers from red/cyan chromatic aberration, particularly where the branches of the tree are against the bright sky.

TRIPODS

After a camera and lens, the next most important piece of equipment for a landscape photographer is a tripod. The principle role of the tripod is to keep the camera steady during an exposure, especially if you are shooting in low light and using lengthy shutter speeds that would make it impossible to keep the camera steady by handholding it.

There are three basic materials used to make tripods: plastic, metal, and carbon fiber. Which one you choose is often a compromise between stability, weight, and cost. Plastic tripods are the least expensive, but they can also be flimsy and won't last as long if they are used frequently. Metal tripods (usually aluminum) tend to be the heaviest, which makes them robust and stable. Carbon-fiber tripods combine light weight and good stability, but often cost twice as much as an equivalent metal tripod.

TRIPOD HEADS

Some tripods come with a fixed camera platform (a tripod "head") that can't be removed, whereas other tripods are sold as legs only, requiring a separate tripod head to be purchased and attached. Although the latter type means buying another piece of equipment (adding to the overall cost), the benefit is that your tripod can be more finely configured to your needs.

The three most common types of tripod head are the three-way heads, ball heads, and geared heads. A three-way head can be adjusted and locked in three different axes using a screw mechanism; a ball head has a ball-and-socket joint that can be unlocked and moved freely to the required position; a geared head is a variation of the three-way head, with the three directional controls moved using geared knobs that don't need to be locked.

Below: This shot required a shutter speed of 1.6 sec. There is no way I could have handheld the camera for that long without seeing camera shake, so a tripod was essential.

USING A TRIPOD

There's more to successfully using a tripod than extending the legs and placing your camera on top—the advantage of using a tripod will be negated if it's not stable.

When extending the legs, make sure that the point where they meet below the head is level. On uneven ground this may mean extending the legs to different lengths to compensate. What you don't want to happen is for your tripod to tip over when your camera is attached (particularly if it tips onto rock or sand), so on soft ground push your tripod down firmly to ensure that it's stable before you fit your camera. A surface such as thick grass can fool you into thinking your tripod is settled on the ground, when it may actually be precariously balanced above the ground.

It is also a good idea not to move around when you are shooting on soft ground—any movement may cause your tripod to shift slightly, resulting in camera shake.

Before you begin shooting, check that all the clips or bolts on your tripod are firmly secured. If you are using a telephoto lens you should attach it to the tripod via a tripod collar if the lens has one fitted. On the subject of lenses, some lenses (and cameras) have built-in image stabilization. These systems can adversely affect image quality when the camera is mounted on a tripod (ironically causing unsharp images), so it's good practice to turn image stabilization off when using a tripod and then switch it back on when you're handholding the camera.

Another way to accidentally cause camera shake is by pressing the shutter-release button down. When shooting on a tripod, use either a remote release (wired or infrared) or use the camera's self-timer. The former is preferable if you need to fire the shutter at a precise moment in time, such as when a wave breaks.

Below: Tripod legs can get very cold when used outdoors in winter (particularly if the tripod is made of metal). Wrapping insulating foam around one of the legs will give you a place to hold the tripod when carrying it.

FILTERS

Filters are generally more necessary when shooting on film than when using a digital camera. However, even though a lot of filter effects can be mimicked using image-editing software, filters still have a place in the digital landscape photographer's kit bag. This is partly because some filters—such as a polarizing filter—cannot be replicated after exposure. It is also because there's something satisfying about using filters to solve a problem at the time of shooting, rather than fixing an image in postproduction.

Filters are available in two forms—screw-in or square/rectangular to fit into a filter holder—and both have their advantages (and disadvantages). Screw-in filters attach to the filter thread at the front of a lens. However, there's no standard filter thread size. If you only have one lens this isn't a problem, but if you have two lenses with different filter thread sizes it means you will either have to buy the same filter for each lens or buy a filter for the largest filter thread size and use step-up rings to convert it for use on your other lenses.

Filter holder systems tend to be a more expensive solution than screw-in filters, but in some ways they are more convenient. A filter holder fits to an adapter ring attached to the lens filter thread. Square or rectangular filters—typically up to a maximum of three—can then be fitted into slots in the filter holder.

The advantage here is that if you buy a new lens you just need to buy a new adapter ring to fit it: you can then use the same filter holder and filters. A filter holder system is also preferable when graduated ND filters are used (see page 20), as these filters need to be moved up or down to achieve the best placement. This isn't possible with a screw-in filter, but straightforward when you are using a filter holder.

NEUTRAL DENSITY (ND) FILTERS

Your camera has three main exposure controls: shutter speed, aperture, and ISO. Together, they allow you to finely control exposure. However, there are situations in landscape photography when it's impossible to use a particular combination of these controls—typically due to the conditions being brighter than desired. The solution is to fit what's known as a neutral density or ND filter. These filters are completely neutral, so they don't add color to an image—their only role is to reduce the amount of light entering a camera, simulating lower light levels and allowing you to set your desired exposure.

ND filters are available in a variety of strengths, with two systems frequently used to show the strength of a filter. The most commonly used system uses increments of 0.1 to represent a $\frac{1}{3}$-stop light loss. Therefore, a 1-stop ND filter has a strength of 0.3; a 2-stop filter is 0.6; a 3-stop filter is 0.9, and so on.

The second system uses "filter factors" to show the strength of the filter. Using this system, a filter offering a 1-stop light reduction is shown as 2x; 4x is equivalent to a 2-stop reduction; 8x is equal to 3 stops, and so on.

A fashionable item at the moment is an extremely dense ND filter that reduces exposures by 6 or 10 stops. These virtually opaque filters allow very long shutter speeds to be used, but because of their density they need to be fitted after an image has been composed and the focus has been set. Even then you may need to calculate the exposure manually using the filter factor specified by the filter manufacturer.

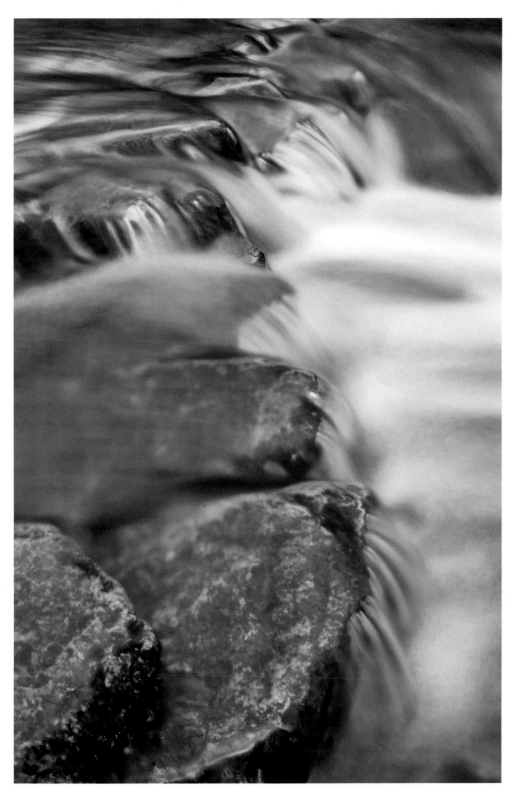

Left: ND filters are usually used in landscape photography to allow slower shutter speeds than the range of apertures on a lens would permit (there's greater scope for adjusting shutter speed than aperture). Slow shutter speeds are used to convey a sense of movement in subjects such as flowing water or wind-blown foliage.

GRADUATED ND FILTERS

A problem faced frequently by landscape photographers is the sky being far brighter than the foreground. When this happens, you can either set the exposure so that the sky is correct (which means that the foreground will be too dark) or expose for the foreground and risk burning the sky out to white. Fortunately, there's a third solution in the form of graduated ND filters (or "ND grads").

ND grad filters are related to plain ND filters, but they are longer, with only half of the filter coated with a semi-opaque ND coated (the other half is totally clear). As with plain ND filters, ND grads are sold in different strengths: the greater the difference in brightness between the sky and the foreground, the stronger the ND grad you'd use.

To use an ND grad you simply fit it into a filter holder, positioning the ND-coated area across the part of the scene you wish to darken (typically the sky). It's important to place an ND grad accurately so you don't leave a bright strip across the bottom of the sky (if the filter is placed too high) or end up with part of your foreground appearing unnaturally dark (if the filter's placed too low).

TIPS

- ND grads are sold in terms of "hardness" as well as strength. This tells you how abrupt the transition from semi-opaque to clear is. Hard ND grads are easier to use and place accurately, while soft ND grads are more useful when the horizon isn't straight.

- If you only want to buy one ND grad, a 2-stop version will typically be the most useful.

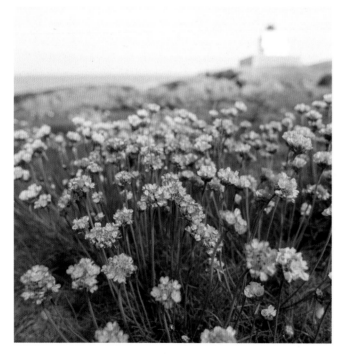
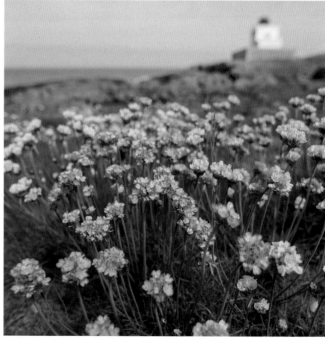

Above: There was no direct light on these flowers, but the background was brightly lit. The correct exposure for the flowers (above left) meant that the sky burnt out. The exposure was balanced by using a 2-stop hard ND grad (above right).

POLARIZING FILTER

A polarizing filter is unique in that its effects can't be replicated either in-camera or during postproduction. There are two main uses for a polarizing filter. The first is to reduce or cut out glare from non-metallic surfaces, such as water and wet leaves (this latter is particularly useful for boosting the color saturation of the leaves). The second use is to deepen a blue sky.

A polarizing filter is made of a glass element that is mounted in a moveable ring that can be rotated through 360°. The strength of the polarizing effect can be adjusted by turning the ring, but it's important to note that a polarizing filter only works under certain conditions: the reduction of glare on a non-metallic surface is only seen when the filter is at roughly 35–45° to the surface (a polarizing filter has no effect when held parallel to the subject), while the deepening of a blue sky is most intense when the filter is at 90° to the sun.

NOTES

- Polarizing filters block approximately 2-stops of light. For this reason they can also be used as ND filters.

- There are two types of polarizing filter: linear and circular. This doesn't refer to their shape, but to their method of construction. If you use a DSLR (or are considering one) then you need a circular polarizing filter, as linear polarizing filters affect the autofocus of a DSLR camera.

- Take care when using a polarizing filter with a wide-angle lens to deepen a blue sky. This combination can result in uneven polarization, creating an unnatural-looking blue band across the sky.

- Avoid using a polarizing filter to deepen the blue of a cloudless sky—it can make the sky appear overly intense and unnatural.

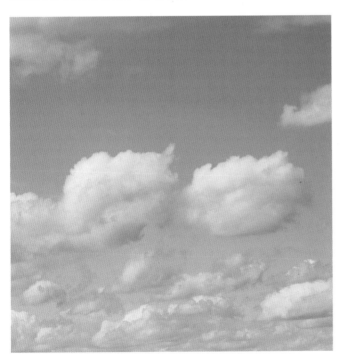
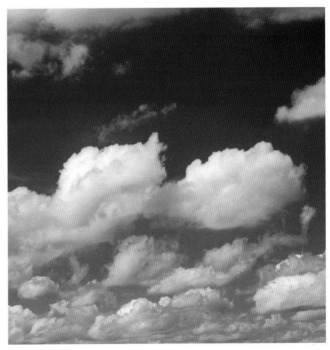

Above: Used carefully, a polarizing filter can add drama to a bland sky (above left), helping clouds stand out (above right).

OTHER ACCESSORIES

Once you have a camera, a lens, and a memory card, there's nothing to stop you from shooting landscape images. However, things can often be made easier with the purchase of other non-essential (but useful) accessories.

The most obvious accessory is a bag to put your camera kit in. Camera bags come in many different shapes and sizes, but the most useful for landscape photography is a rucksack-style bag that you carry on your back. Landscape photography invariably requires walking to reach a location and a bag with two shoulder straps is a lot more comfortable to wear for long periods of time than a bag with only one strap.

Another useful feature is a waist strap that distributes the weight still further and eases the strain on your back. A good bag should be robust and weatherproof (or even waterproof if possible), with moveable dividers inside that

allow you to distribute your camera equipment effectively and safely.

Shooting at sunrise or sunset often means dealing with camera flare, which is caused by light from a point light source (such as the sun) bouncing around the glass elements inside the lens. The result is color shifts and a reduction in contrast in your images. Modern lenses are less prone to flare than older lenses due to the use of flare-resistant coatings on the lens elements, but it is still worth investing in lens hoods for your lenses (although a small piece of card can also be used to shade your lens when flare is likely).

Below: A lens hood won't stop flare if the light source is shining directly into the lens, but it will stop flare from light shining just outside the camera view. The flare in this shot was caused because the sun is just out of shot at the left—on this occasion, a lens hood would have very effectively prevented it.

Above: A lens hood is beneficial when you use filters, as they are prone to flare, especially if you combine more than one. Here I used both a polarizing filter and a 2-stop ND filter—plus a lens hood.

EXPOSURE

In photography, exposure has two subtly different, but connected meanings: to "make an exposure" is the act of creating an image, while an image's exposure refers specifically to the amount of light that is required to make that image.

Cameras come in many forms, but the basic principles of how they work are common to virtually all of them. A camera is essentially just a box containing a surface that is sensitive to light—in a digital camera this surface is the imaging sensor. The amount of light that reaches the sensor is controlled in two ways. The first control is a variable aperture inside the lens, and the second control is a curtain in front of the sensor, known as the shutter. The shutter can be opened for a very precise period of time, which is referred to as the shutter speed.

One big difference between camera models is the amount of control you have over the shutter speed, aperture, and a third exposure variable—ISO. The more

automated the camera, the less able you are to influence how a picture is shot. Cell phone and compact cameras often fall into this category. This makes them easy to pick up and quickly shoot an image with, but successful landscape photography often requires you to step in and take control of the exposure.

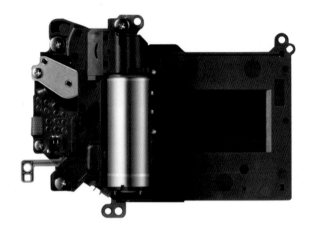

Above: Shutter mechanisms—such as this one from a Canon EOS 70D— are complex and precise devices. Image © Canon

Left: Understanding and then taking control of exposure is extremely satisfying. It's almost physically painful to come home from an otherwise successful photography session to find that your images are not exposed correctly!

Right: This is the type of scene that a camera's built-in lightmeter will generally get right. Although there are bright and dark patches they essentially cancel each other out, creating an average tonal range across the image.

CAMERA METERING

All modern cameras have built-in exposure meters that measure light, so that the correct exposure can be determined. This meter is known as a "reflective meter" because it measures the amount of light being reflected from the scene back to the camera. This is different to the handheld lightmeters sometimes used by photographers, which are known as "incident meters" because they measure the amount of light falling onto the scene. It's a subtle, but very important difference.

A reflective meter in a camera makes a very big assumption about the scene being metered. It assumes that the scene has "average" reflectivity—not too much, nor too little. An averagely reflective scene has an overall reflectivity similar to a mid-gray.

Unfortunately, not every landscape scene has such an obliging average reflectivity. Scenes that have a higher or lower reflectivity can cause exposure problems. A scene such as a vista of snow is highly reflective (and so has higher-than-average reflectivity). In this instance a camera meter will tend to underexpose the image, as it will try to create an exposure in which that great swathe of white is a muddy midtone.

The opposite is true of a scene with a lower-than-average reflectivity. In this case, the camera meter will cause overexposure, as it tries to create an exposure that turns the dark tones into a midtone. Although this sounds frustrating it is surprisingly easy—with practice—to recognize when a camera's lightmeter will be fooled and to compensate accordingly.

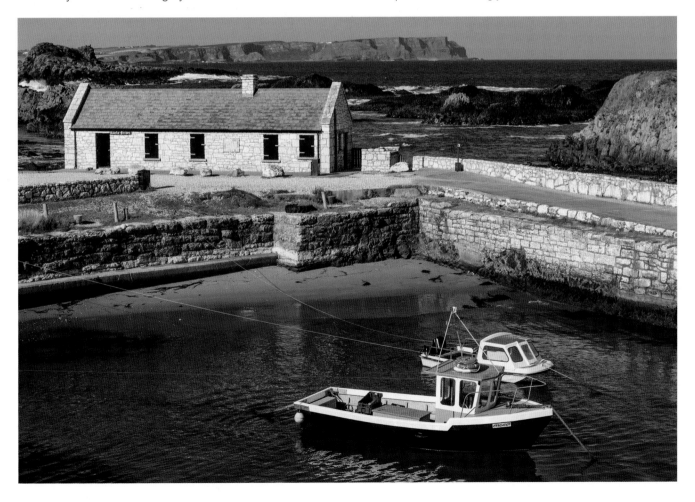

CAMERA METERING MODES

Although the principle of reflective metering is fairly straightforward, its application is complicated by the fact that cameras usually offer the choice of three different metering modes.

Each mode has strengths and weaknesses, so it is a good idea to experiment with the modes so you can gain an understanding of how each one works and learn which one to use for a particular shot.

Evaluative (also known as Matrix or Multi-area) metering is the default metering mode for modern cameras. Evaluative metering divides the image into a large grid of cells or zones, and each cell is metered separately to the others. The final exposure is calculated by combining the results from each cell, and weighting the results according to the type of scene the camera has decided is being shot (often taking the position of the focus point into consideration too). Evaluative metering is generally accurate, but it can still be fooled into making an error if the focus point is over an area that is lighter or darker than average. Care must also be taken when using filters, particularly ND grads.

Center-weighted metering pre-dates Evaluative metering as a technology, but that doesn't mean that it's not worth considering. When a scene is assessed using center-weighted metering, the exposure is biased more to the center than the edges. How great the level of bias is depends on the camera, but 60% isn't an unreasonable assumption. Center-weighted metering is often more consistent than Evaluative metering, as it ignores information such as the focus point when determining the exposure.

Spot metering forces the camera to meter from a very small part of the scene: typically somewhere in the region of 1–5% of the image area. This is usually at the center of the image (and the area is often marked in the viewfinder by a circle), but some cameras allow you to link spot metering to the active focus point. Spot metering gives you very precise control over where the camera meters from, but it can also lead to the wrong result if you don't take your meter reading from a midtone area.

SHOOTING MODES

In general, the more expensive a camera is, the fewer shooting modes it is likely to have. Cameras aimed at enthusiasts have a wide range of shooting modes, including some that are designed for specific situations, such as photographing landscapes. However, these automatic modes lock you out of adjusting many of the camera functions, so to take full control of your camera the PASM modes (Program, Aperture Priority, Shutter Priority, and Manual) are a better choice.

Program (often shortened to P) is an automatic exposure mode, but one in which the exposure chosen by the camera can be overridden (either by shifting the exposure values chosen by the camera or by using exposure compensation). Program has one major flaw for landscape photography: with most cameras it tends to favor a fast shutter speed (to make it easier to handhold the camera and avoid camera shake) rather than a smaller aperture (necessary for extending depth of field).

For this reason, Shutter Priority and Aperture Priority (shortened to S or A respectively, although Canon and Pentax use Tv and Av) are often preferable. These semi-automatic modes allow you to choose one exposure variable (the shutter speed in Shutter Priority and the aperture in Aperture Priority) leaving the camera to select the other one. Of the two modes, Aperture Priority is the most useful for landscape photography, as it allows you to control depth of field by selecting the required aperture.

You still have to be aware of the automatically selected shutter speed, but if the camera is mounted on a tripod, issues such as camera shake are not as important.

The final option—Manual, or M—puts you in control of both the shutter speed and aperture setting. As a general shooting mode it is not recommended, but it is worth experimenting with when you want total control.

TIPS

- As already described, there are situations that can fool camera meters. When shooting in Program, Aperture Priority, or Shutter Priority you don't necessarily need to use the exposure suggested by the camera. Cameras have a function called exposure compensation that allows you to increase the level of exposure (by setting positive compensation) or decrease the level of exposure (by setting negative compensation). This function is incredibly useful for correcting exposure errors, and also when you want to adjust the exposure for creative effect.

- Most cameras will allow you to bracket your exposures. Bracketing is a function that sets the camera to automatically shoot a number of shots (usually three): one at the "correct" exposure, one with negative exposure compensation applied (to produce a darker image), and one with positive exposure compensation applied (to give a lighter result). Bracketing is a useful safety net if you're not sure about the exposure, as it gives you a number of options to choose from. However, it does mean that your camera's memory card will fill more quickly.

Left: I use Aperture Priority mode most often, as depth of field is usually more important for my photographs than the shutter speed.

APERTURE

The aperture is an iris built into a lens. It can be varied in a set series of steps to precisely control the amount of light that passes through the lens. These steps are referred to as "f-stops" (shown as "f/" followed by a number), or simply "stops." When the aperture is at its widest, the lens is said to be set at its maximum aperture. Different lenses have different maximum aperture settings; typically, prime lenses have larger maximum apertures than zooms. A lens with a large maximum aperture is described as a "fast" lens; a lens with a small maximum aperture is "slow."

The most counterintuitive aspect of the f/stop range on a lens is that larger apertures are referred to using a small number (such as f/2.8), whereas small apertures use a larger number (such as f/22). The reason for this is that the f/stop value is actually a fraction—it shows the size of the aperture as a fraction of the focal length of the lens. For example, if you set f/4 on a 50mm lens, the aperture

in the lens would be 12.5mm in diameter (50/4=12.5). However, you really don't need to know that much information, only that there's a reason for what at first sight seems a peculiar numbering system.

A typical range of f-stops on a lens is f/2.8, f/4, f/5.6, f/8, f/11, f/16, and f/22. Each f-stop value in the sequence represents a halving of the amount of light that passes through the aperture, compared to the value before it. This also means that each f-stop value in the sequence represents a doubling of the amount of light let through the aperture compared to the value that follows it. In this way, f/8 allows twice as much light through the lens as f/11, but half as much as f/5.6.

There are two ways you can set the aperture: some lenses allow you to set the aperture by turning a ring on the lens to physically open or close the aperture, but most camera systems now use a dial on the camera to set the aperture electronically.

Above: Changing the aperture on an old, manual focus Nikon prime lens may look like a clunky way to do things, but it's surprisingly satisfying!

NOTES

- Altering a control to allow half or double the amount of light to reach the sensor is an important concept, as this adjustment is known as altering the exposure by "1 stop."

- The aperture sequence shown here refers to full f-stop values—on most cameras the aperture can usually also be altered in fractions of a stop (typically in either ½- or ⅓-stop increments).

DEPTH OF FIELD

Altering the aperture has another function on a camera, aside from determining how much light passes through the lens—it also controls how much or how little of an image is sharp. When a very simple lens is focused, only a thin plane at the point of focus parallel to the lens is sharp (this is referred to as the "plane of focus"). On either side of this plane the image becomes progressively unsharp.

The aperture in a lens controls the depth of field in an image. This is a zone of sharpness that extends forward and backward from the point of focus. Depth of field always extends roughly twice as far back from the point of focus than it does forward, and it increases the smaller you set the aperture: so the depth of field (zone of sharpness) at f/16 will be much greater than it is at f/4, for example.

To complicate things, there's more to depth of field than how the aperture is set—it is also affected by the focal length of a lens. The longer the focal length, the less inherent depth of field there is at a given aperture, so if you had a 150mm lens and a 24mm lens and used them both at f/8, the depth of field from the 150mm lens would be much shallower. This is generally not too much of a restriction for landscape photography, which often involves using wide-angle lenses. There is also a method, known as the hyperfocal distance, that allows you to maximize the depth of field at any aperture, as described on page 42.

The final factor to be taken into consideration is that the camera-to-subject distance also affects depth of field: the closer the subject, the less depth of field there will be. Again, for most landscape photography this is usually not a big problem. However, it does make life more difficult when shooting close-up shots, or if the main subject is particularly close to the camera relative to the background.

Below: Getting the depth of field right is more critical when your scene is very "deep." This shot required the use of a very small aperture (f/20) to ensure front-to-back sharpness as the foreground was close to the camera and the background was relatively distant.

Below: This scene is essentially two dimensional, as it's all background. This meant that a more modest aperture of f/11 was all that was needed to keep everything sharp.

SHUTTER SPEED

The shutter speed determines how long the shutter is open to allow light to reach the sensor and make an image.

The shutter speed range of a camera often starts at a blindingly fast 1/4000 sec. (a speed that is rarely used in landscape photography) and goes down to a glacial 30 sec. Some cameras also have a Bulb (B) setting, which holds the shutter open for as long as the shutter-release button is held down.

Between 1/4000 sec. and 30 sec. you can set the shutter speed in a series of steps: 1/2000 sec., 1/1000 sec., 1/500 sec., 1/250 sec., 1/125 sec., and so on. As with the aperture, the difference between these values is referred to as 1-stop, with each stop representing a halving of the light allowed to reach the shutter (as you use a

faster shutter speed) or a doubling of the light reaching the sensor (as you use a slower shutter speed).

The shutter speed you choose is important in many ways. If you're handholding your camera, a slow shutter speed is more likely to result in camera shake, especially when you are using a telephoto lens. The shutter speed is also important if there is movement in the scene, as it will determine how the movement is rendered in the final image. The faster the shutter speed, the more movement is frozen. Fast shutter speeds are therefore necessary if you want to capture the individual drops of water on a breaking wave, or record an animal in pin-sharp detail as it runs across a landscape. Slower shutter speeds are used to blur and soften movement. This is a technique that is frequently used when shooting moving water.

NOTE

- The shutter speed sequence given above refers to full stop values. The shutter speed on a camera can usually also be altered in ½- or ⅓-stop increments. As an example, 1/80 sec. and 1/60 sec. are the ⅓-stop values between 1/100 sec. and 1/50 sec.

Left: Fast shutter speeds are often required when shooting delicate subjects such as plants, which are easily disturbed by currents of air. A fast shutter speed will freeze any movement caused by this disturbance.

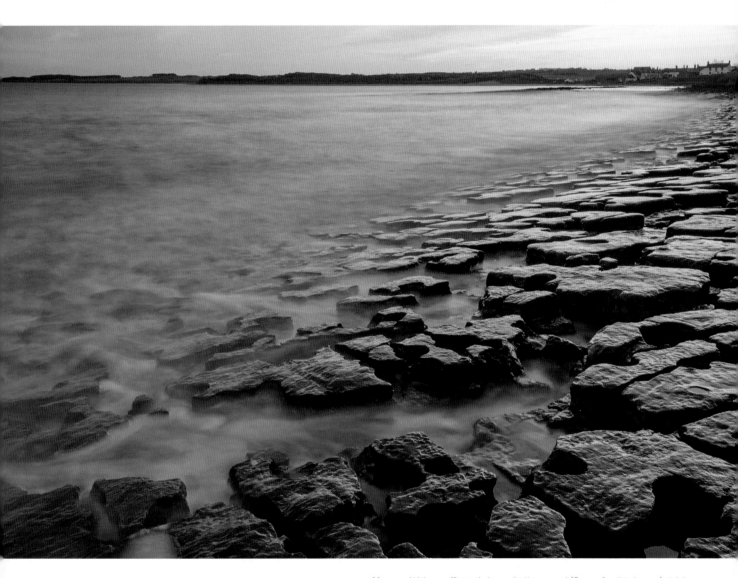

Above: With a sufficiently long shutter speed (8 sec. for this image), tidal water takes on a misty, milky appearance.

ISO

The shutter speed and aperture physically control the amount of light that's allowed to reach the sensor during exposure. However, the precise amount of light that's actually needed for a correctly exposed image is controlled by the ISO setting on your camera.

The lowest ISO setting on a camera is known as its base setting, and this is typically ISO 100 or 200 (although some cameras offer extended settings that mimic ISO 50). The ISO range increases numerically: 100, 200, 400, 800, 1600, and so on. Each figure, reading from left to right, signifies an increase of sensitivity of 1-stop, meaning that half as much light is required to make an exposure as you increase the ISO (with the reverse being true if you read from right to left).

At the base setting the sensor is at its least sensitive to light. In low light this means you will need to use either a large aperture or an extended shutter speed to successfully make the correct exposure. Increasing the ISO setting increases the sensitivity of the sensor, so in low light you could therefore use a smaller aperture or faster shutter speed than at base ISO. However, this isn't always ideal, as increasing the ISO risks introducing "noise" into an image.

Noise is essentially corrupted image data that's seen as random spots of color or variations in the brightness in an image. It affects fine detail in an image, so the more noise there is, the greater the risk that detail in the image will be lost. Noise is generally more noticeable in areas of even tone, such as skies or shadows.

There are two types of digital noise: luminance and chroma. Chroma noise is the least welcome and is seen as ugly color blotches across an image. Luminance noise adds a gritty texture to an image, and is usually seen first as the ISO is increased, with chroma noise restricted to high ISO settings. The precise ISO settings that cause both the appearance and type of noise are dependent on the sensor inside the camera.

NOTES

- The size and age of a camera's sensor are two important factors in its susceptibility to noise. Modern camera sensors are generally able to use higher ISO settings without noise becoming intrusive compared to older sensors. Also, the larger a camera sensor is, the less prone to noise it will be, so at a given ISO setting a full-frame sensor will generally outperform the sensor in a compact camera.

- Although noise is usually best avoided if possible it does suit certain types of imagery. Moody black-and-white shots often benefit from the gritty quality caused by noise.

- As with the aperture and shutter speed, most cameras allow you to set the ISO in ½- or ⅓-stop increments.

Below: Shooting in woodland often means working in low light. This image of a woodland stream was shot at ISO 100. Rather than use a larger aperture, I chose to use a longer shutter speed (2 sec.) to ensure the correct exposure.

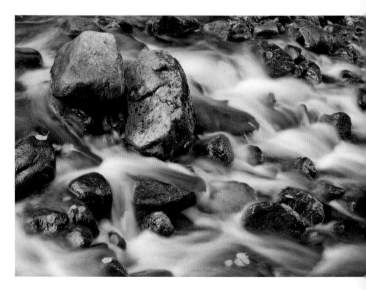

CHOOSING AN ISO VALUE

Ideally, you should use the base ISO setting when shooting landscapes, as this will maximize image quality. However, this does mean compromising either depth of field (by using a large aperture) or allowing anything moving in the scene to become blurred and potentially even vanish entirely (because the shutter speed needs to be extended). Usually, depth of field is most important for landscape photography, so the compromise is usually biased toward using longer shutter speeds.

As well as fixed ISO settings, your camera will also allow you to use Auto ISO. This setting allows the camera to dynamically alter the ISO, depending on the ambient light levels. This is a useful option if you're handholding your camera, as Auto ISO can increase the ISO so that a faster shutter speed can be selected to avoid camera shake.

However, Auto ISO should always be avoided when using a tripod, especially if you're also using light-sapping filters such as a polarizing filter, as these will fool your camera into using a higher ISO than is perhaps desirable.

Another reason to use your camera's base ISO is that there's greater latitude for making tonal adjustments in postproduction than when using higher ISO settings. Both color fidelity and dynamic range (see page 35) are reduced when using a high ISO setting.

Below: A high ISO setting is useful when you want to use a fast shutter speed to prevent any movement being recorded as a blur. For this shot, using a large aperture (f/5.0) and ISO 400 allowed me to shoot at 1/400 sec. and freeze this flower in the breeze.

NOTES

- Underexposing an image by 1 stop and then correcting the exposure in postproduction is the same (in terms of the visibility of noise) as increasing the ISO by 1 stop at the time of exposure.

- The appearance of noise can be reduced either in-camera or in postproduction, although in-camera noise reduction is more important when shooting JPEG than Raw. Generally, it's preferable to tackle noise in postproduction as you have more control over the level of noise reduction. In-camera noise reduction (or applying it too enthusiastically in postproduction) can make an image appear unnaturally smooth. There's a fine line between noise and real texture in an image—heavy-handed noise reduction can reduce the appearance of both, to the detriment of the image.

RECIPROCAL RELATIONSHIP

The three exposure controls—shutter speed, aperture, and ISO—are interlinked, so if you change one, you have to change at least one of the other two to maintain the same level of exposure overall.

As an example, let's say that at ISO 100 the suggested shutter speed and aperture is 1/30 sec. and f/8 respectively. These last two settings may suit your needs perfectly, but for aesthetic reasons, you might prefer to use a slower shutter speed instead—1/4 sec., for example. The difference between 1/30 sec. and 1/4 sec. is 3 stops (1/30 sec. > 1/15 sec. > 1/8 sec. > 1/4 sec.). You would therefore need to adjust either the ISO or aperture by 3

stops to maintain the same level of exposure overall. In this instance, the ISO is at its lowest setting, so only the aperture can be changed—it would need to be reduced to f/22 (f/8 > f/11 > f/16 > f/22) to compensate for the shutter speed adjustment.

Below This photo was shot using an exposure of f/11 at 1/125 sec. I could also have used any combination of shutter speed/aperture below to achieve the same level of exposure.

APERTURE (F-STOP):				
f/5.6	f/8	f/11	f/16	f/22
SHUTTER SPEED (SEC.):				
1/500	1/250	1/125	1/60	1/30

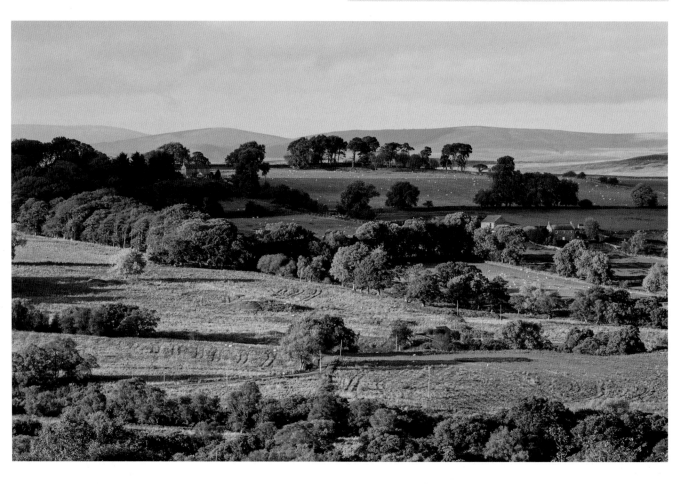

DYNAMIC RANGE

It is important to appreciate that a camera doesn't "see" in the same way as you. This can prove frustrating until you learn to understand the limitations of cameras and adjust your expectations accordingly.

One of the ways in which a camera differs from human vision is its inability to record as wide a range of brightness levels as can be seen with the eye. This is particularly noticeable when shooting a high-contrast scene, when it is often impossible to set the exposure to record detail in both the highlights and the shadows. Consequently, you usually need to compromise by biasing the exposure one way or the other—underexposing to preserve detail in the highlights and losing detail in the shadows, or overexposing so that the highlights are burnt out, but detail is retained in the shadows. The range of brightness levels that a camera can record is known as its dynamic range.

There are several ways to deal with scenes that exceed the dynamic range of a camera. The first is to return on a different day when the scene is less challenging, while another option is to reduce the contrast before you shoot. When shooting close-ups this can be achieved by using

reflectors to push light back into the shadows, or diffusers to soften the light falling onto your subject. Clouds act as natural diffusers, reducing contrast across a larger area.

In landscape photography, the most common test of a camera's dynamic range comes when shooting a relatively dark foreground in combination with a bright sky. This problem requires you to either make a series of exposures that record detail in both areas or then blend the shots in postproduction, or use ND grad filters to achieve the same effect in-camera.

NOTES

- Increasing the ISO on your camera reduces the available dynamic range.

- The smaller the sensor in a camera, the lower the inherent dynamic range. This means that highlights are more likely to burn out without applying heavy negative compensation.

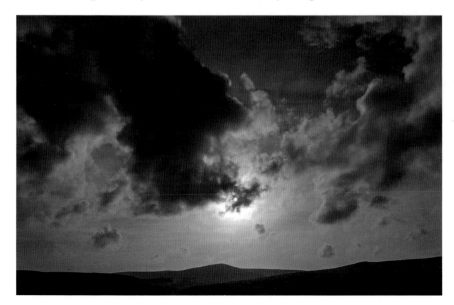

Left: Shooting into the light puts a camera's dynamic range to the test. In this instance the camera I used was just about able to retain some detail in the brightest highlights (the sun and the cloud around it) without losing too much detail in the darkest areas.

HISTOGRAMS

A huge advantage of digital capture over film photography is the availability of a histogram as an aid to image exposure. "Live" histograms can often be displayed on the LCD screen when you are shooting using Live View, although some cameras can only display a histogram next to an image in playback, after it has been shot. Both types are useful, although a Live View histogram will help you make exposure decisions before the shutter is fired.

A histogram is simply a graph that shows the tonal range of an image. The extreme left edge of the histogram shows the number of pixels in an image that are pure black. From the left edge to the center of the histogram is the distribution of tones in the image that are darker than a mid-gray (the vertical axis of the histogram shows the number of pixels in the image of a particular tone). From the middle to the right edge is the distribution of tones that are lighter than a mid-gray. The extreme right edge shows you how many pixels in the image are pure white.

There's no right or wrong shape for a histogram, but if it's skewed to the left it's a good indication that the image may be underexposed (unless the scene is comprised primarily of dark tones). If it's skewed to the right this is an indication that the image may be overexposed (unless the scene is made up of mainly light tones, such as a snowy landscape). If possible, the exposure should be set so that the histogram isn't squashed up against either edge—if this happens the histogram is said to be "clipped," which means the image contains pixels that are pure black or pure white. These pixels contain no usable image information so recovering any detail will be impossible in postproduction.

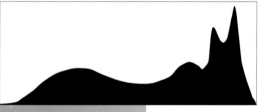

Above & Left: The histogram for this snow-dominated landscape is biased to the right, which is the correct histogram for this shot. Notice that the histogram doesn't clip the right edge, indicating that there is still desirable textural detail in the snow.

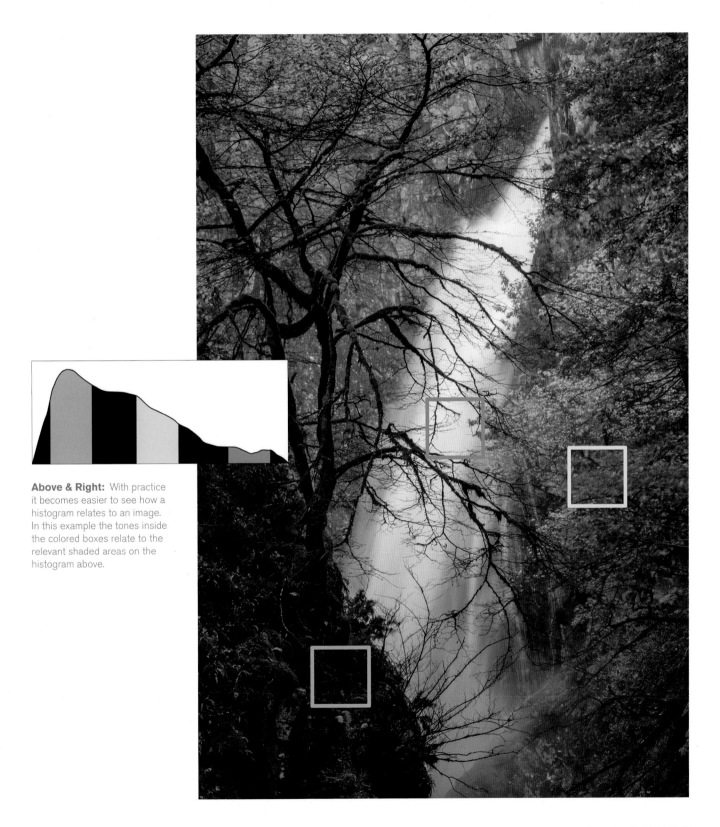

Above & Right: With practice it becomes easier to see how a histogram relates to an image. In this example the tones inside the colored boxes relate to the relevant shaded areas on the histogram above.

FILE FORMATS

Regardless of brand, most cameras have a range of basic shooting functions in common. This lesson explores these common functions and looks at how you can use them to their best advantage when shooting landscape images.

FILE FORMATS

System cameras (and some of the more highly specified compacts) offer two image file types: JPEG and Raw (if there's only one file type available it will almost certainly be JPEG). When there's a choice in photography there are generally advantages and disadvantages to each option, and this is true of JPEG and Raw.

JPEG

JPEG stands for nothing more exciting than "Joint Photographic Experts Group"—the name of the group that invented the file format. There are many advantages to shooting JPEGs, starting with the file format's compatibility. JPEGs are compatible with many different computer programs, including word processors and desktop publishing packages. JPEG is also used extensively on the Internet for the display of photographic images.

Another advantage of a camera JPEG is that it's a "finished" image, ready for use as soon as you've copied it from the memory card. This saves time, as little or no postproduction work is required.

NOTES

- JPEGs take up less space on a memory card than a Raw file: typically you can fit two high-quality JPEGs to one Raw.

- Both JPEG and Raw file data is compressed by the camera to save memory card space, but the compression methods used are different. JPEG compression reduces the quality of the image (throwing away fine detail to a lesser or greater degree), whereas Raw compression doesn't affect the image quality of the file. The latter is referred to as "lossless" compression.

Left: This image (far left) has been saved as a JPEG using maximum compression in Adobe Photoshop. Close-up (left) it's possible to see the damage done to the image. Fortunately, cameras don't usually apply such an extreme level of compression.

This immediacy is due to the camera applying functions such as white balance and picture styles to the JPEG at the moment of capture (effectively "baking" them into the image file). Although this makes shooting JPEGs very convenient, it does mean that you need to decide exactly what effect you want before shooting. If you decide later that the effect is unwanted then it's hard to unpick the settings without an unacceptable drop in image quality.

RAW

Raw files are a package created by the camera and containing all the image data captured at the time of exposure. No processing is applied to this data, although functions such as the current white balance setting are "tagged" to the Raw file. This means that when you open a Raw file on your computer the tagged information can be used, but it can also be easily altered. This is the great strength of Raw: you're not constrained by the settings chosen before shooting, other than exposure (although even then there is more latitude for fine tuning the exposure than there is with a JPEG file). In this way, Raw files allow you to make multiple interpretations of an image, whether it's converting it to black and white or merely refining the white balance. This is all done without any loss of quality.

The downside is that Raw files must be processed before they're ready for use. This can sometimes be achieved in-camera (albeit to a very limited extent), but will most often be something that is done using dedicated Raw conversion software such as Adobe Lightroom or Apple Aperture. Even then, the Raw file needs to be exported as a different file type—such as JPEG or TIFF—if you want to use it in other types of software.

If you shoot on a regular basis then you will find that you need to allocate almost as much time for processing your Raw files as it takes to shoot them to start with. However, there's a lot to recommend shooting in Raw, as it gives you the greatest control over your images, allowing more scope for personal interpretation than JPEG.

Below: You never overwrite the data in a Raw file. Instead, any changes you make are either stored in a Raw converter's database or as a separate .XMP file alongside the Raw file on your computer. This means that Raw files are infinitely malleable without any loss of quality. As your skills develop, you may even find yourself revisiting old Raw files to convert them differently in light of your gained experience, as demonstrated below. With a JPEG, you will always be stuck with the decisions that you or the camera made at the time of shooting.

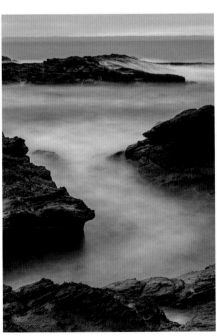

PICTURE CONTROLS

If you've ever shot with a film camera you'll know about the bewildering range of film types that are available. Some types have vivid color and high contrast, while others are subtler, with subdued color and contrast. Digital cameras offer you the same level of control over the look of your images, with the added benefit that you can do this for each individual image you shoot, and not just when you reach the end of a roll of film.

Some of these picture controls, known as picture parameter presets, will be grouped together under a brand-specific name on the shooting setting menu of your camera (Canon calls them Picture Styles, for example, and Nikon uses Picture Controls, although they're essentially the same thing). Generally speaking, picture parameter presets allow

Above: This image was shot using my camera's Landscape picture parameter preset. The scene was already high in contrast, but the Landscape setting has boosted the contrast even further. In retrospect, a setting with lower contrast (such as Standard) would have been a better choice here.

COMMON PICTURE CONTROLS

DESCRIPTION	TYPICAL OPTIONS	SUGGESTED SETTING
Color space	sRGB; Adobe RGB	Use Adobe RGB if you intend to alter your image in postproduction; use sRGB if you want to print your image or upload it to a website directly after shooting.
Dynamic range control	Off; Low; Medium; Strong	Adjusts the highlights and shadows in the image to create a more balanced tonal range. The strongest setting often produces less-than-naturalistic results.
Lens correction	Vignetting; Chromatic aberration correction	Enable this option if you feel your lens requires help! This is more important when shooting JPEG, and it is worth noting that third-party lenses aren't usually supported.
Picture parameter presets	Standard; Portrait; Landscape; Neutral; Vivid; Monochrome	Set these according to taste. The Standard option generally produces the most naturalistic results, while Landscape often boosts contrast and increases the vividness of greens and blues. This gives your landscape shots more impact, but it is not always a subtle effect!

you to choose options for specific shooting situations such as Landscape or Portrait, or create your own parameters by adjusting sliders to set controls such as contrast, sharpness, and saturation.

How you set the picture parameter presets is more important when shooting JPEG than Raw, as the settings can be easily unpicked and changed in postproduction with a Raw file. It's worth experimenting with your camera's picture controls to find a look that you prefer, as there's no right or wrong answer—ultimately it's your personal interpretation! The grid opposite details other controls that you may be able to set on your camera to determine how the image is recorded.

DRIVE MODE

The drive mode of a camera determines how often a shot is taken. Set the drive mode to Single and one shot is taken every time you press and then release the shutter-release button. The alternative is Continuous, which allows you to keep on shooting for as long as you keep your finger on the shutter-release button (although shooting will stop automatically when there's no space left on the memory card or when the camera's frame buffer is full). As landscape photography isn't usually a speed event, Single shot is generally more appropriate.

Another useful drive mode is the camera's self-timer, which counts down to fire the shutter after the shutter-release button has been pressed. Although ostensibly designed for moments when you want to appear in shot yourself, it is also useful when shooting on a tripod when you want to avoid knocking or disturbing the camera at the moment of exposure.

If you're shooting using a DSLR, you should also consider using mirror-lock if available. Slightly ironically, the force of the mirror swinging up before an exposure can introduce a minute tremor in the camera, resulting in a slightly unsharp image. Mirror-lock avoids this by allowing you to flip the mirror up manually and allowing the camera to settle before you make your exposure. The problem with this is that you can no longer see through the viewfinder when the mirror is raised, so it should therefore only be used when your

camera is mounted on a tripod and after your composition has been set. Mirror-lock isn't necessary when using Live View, as the mirror is already swung up out of the way.

NOTE

- The frame buffer is a temporary store for images before they're saved to the memory card. This can create a bottleneck when using Continuous drive mode, as a camera will stop shooting when the buffer fills. You won't be able to begin shooting again until images have been written to the card. However, this is not a problem landscape photographers generally face on location!

Below: A camera's self-timer is ideal for triggering the shutter to photograph subjects that move slowly (if at all), such as this scene.

FOCUSING

There are essentially two ways to use depth of field (see page 20): you can restrict it so that only a small amount of the image is sharp, or you can maximize sharpness so that everything in the image appears in focus. Which you choose will depend on your subject matter and the effect you are trying to achieve.

As a rule, we don't like to linger on unsharp or blurred parts of an image, so restricting depth of field and focusing precisely on the intended subject is a good way to direct a viewer's attention to that subject. The effect is most easily achieved through the use of a telephoto lens set at its maximum aperture (the effect is harder to achieve with wide-angle lenses as they have inherently more depth of field). The effect is also more pronounced the closer your subject is to the camera.

Maximizing the available depth of field also requires careful focusing. You might think that using a lens' minimum aperture setting would be all that's required, but unfortunately, a lens is optically at its peak when set to a mid-range aperture—if you use the minimum aperture then images risk looking soft due to the effects of diffraction.

Fortunately, there is a technique known as hyperfocal distance focusing that helps you to maximize the available depth of field at a given aperture. The hyperfocal distance is the focus distance at which everything from half that distance to infinity will appear sharp at a given aperture.

However, there is no single distance, as it depends on the focal length being used, the aperture setting, and the camera's sensor size. Thankfully, there are numerous apps and online resources (such as www.dofmaster.com, for example) that will determine the hyperfocal distance for any lens/aperture/sensor size combination. Actually setting the hyperfocal distance can prove challenging, though, as many modern lenses don't have a distance scale on them, leaving you to guess where you should be focusing.

Above: This image was shot at f/2.8 to minimize depth of field. Careful focusing (on the flower head at the top of the picture) was required to ensure that it was sharp.

WHITE BALANCE

Neutral white light is light that is composed of an even mix of wavelengths that correspond to the colors we perceive as the standard visible spectrum (red, orange, yellow, and so on, through to violet).

However, most light sources that we believe to be neutral actually aren't. Household lighting often has a strong orange bias, for example, but we tend not to be aware of this unless the color bias is particularly strong or two different light sources are seen together.

The bias in the color of a light source is referred to as its color temperature, which is measured using the Kelvin (K) scale. Light sources with a red/orange bias have a low color temperature, so household lighting typically has a color temperature somewhere between 2800–3400K. Light sources with a blue bias have a higher color temperature, so the ambient light in shade is generally in the range of 7000–8000K.

White balance is a camera function that can be used to compensate for the bias in a light source. Cameras can either apply white balance automatically (a mode often shortened to AWB) or you can manually assign a preset value that is designed to be used when shooting under a particular type of light. The symbols commonly used are shown in the grid below. White balance neutralizes the color bias in a light source by adding the right amount of the opposing color on a standard color wheel (above). So, for example, an orange light source will be neutralized by the addition of blue to an image.

COLOR TEMP.	NOTES	WB PRESET
1800K	Candlelight	–
2000K	Sunrise/sunset	–
2500K	Flashlight	–
2800K	Domestic lighting	💡
3400K	Fluorescent lighting	🔆
3500K	Early morning/late afternoon sunlight	–
5200K	Midday sunlight (winter)	–
5500K	Midday sunlight (summer)	☀️
5500K	Electronic flash	⚡
6000–6500K	Overcast conditions	☁️
7000–8000K	Shade	🏠
–	Auto white balance	AWB
–	Custom white balance	📷

CUSTOM WHITE BALANCE

A camera's white balance presets are useful, but they can be a blunt instrument. Fortunately, cameras generally offer at least one of two ways to refine the white balance.

The first method requires you to choose a specific Kelvin value as your white balance setting. The choice is generally from a range starting at around 2500K and finishing at 10,000K, adjustable in 500K increments (the range is camera specific and varies between models). This is useful, but only if you know the required Kelvin value.

More useful is the ability to set a custom white balance. The way this is set varies between camera models, but the basic premise is that you photograph a neutral gray or white surface under the same lighting conditions as your subject. The camera assesses the color of the light falling onto the surface and determines how much correction needs to be applied in order to achieve a neutral result. This adjustment is then applied to each successive shot.

A custom white balance is very useful when shooting in overcast light, when it's generally more accurate than the camera's automatic option and is often subtler than the Overcast preset option. It is also excellent for achieving accurate color in woodland, as the greens of summer foliage can cause the camera's auto white balance to add too much magenta to an image (as the camera mistakenly tries to compensate for the overall green bias). Red and orange autumnal foliage can cause the camera auto white balance to cool down the image for similar reasons.

Above: I created a custom white balance when shooting this autumnal woodland scene rather than relying on the camera's automatic mode.

Right: The main image (top right) was shot mid-afternoon on a summer's day using the Daylight white balance preset: the colors appear natural and pleasing. Set to Incandescent (tungsten) the image takes on a blue color cast that looks decidedly unnatural (bottom left). Equally unusual is the same image taken with the Shade preset—in this example the greens of the foliage are overly yellow and the sky looks anaemic (bottom right).

DEPTH OF FIELD

Aim: Take a series of images at different aperture settings to minimize and maximize depth of field.

Learning objective: To explore how the aperture setting can be used to control depth of field.

Equipment checklist:
• Camera and lens with moderate wide-angle focal length (approx. 35mm in full-frame terms)
• Tripod
• Filters (optional)

Brief: Landscape photography often relies on an image being sharp all the way from the immediate foreground through to the background. This gives the impression that—if the image were big enough—you could step right into it. However, an image doesn't always need to be sharp all the way through. In fact, minimizing the zone of sharpness can, for some subjects, be just as effective and powerful.

For this project mount your camera on a tripod and compose a shot using a moderate wide-angle focal length (the equivalent of 35mm in full-frame terms). Select a scene with a distinct "subject" (such as a small boulder) that is around 4 feet (1.2m) from the camera. Try to frame the shot so that it also has a middle ground and a distant background.

Set your camera to Aperture Priority and select the lens' maximum aperture. Focus precisely on your subject (you may need to move the AF point so that it covers your subject to achieve this). Without moving your camera, shoot a series of images, making the aperture smaller in 1-stop steps as you do so. Use the full range of f/stops available to you, until you reach the smallest aperture on the lens.

When you have finished, set the aperture back to its maximum setting. Take three more shots, but this time do not change the aperture. Instead, focus on the subject for the first shot, then move the focus point to the middle distance in the scene for the next shot. Finally, move the focus point to the far distance for the final shot.

Above: This is the classic landscape photography approach, with everything from the foreground to the background appearing sharp. This was achieved by using a wide-angle lens and an aperture of f/14.

Right: In this shot, the subject is the rocky foreshore; the middle distance is the sandbank and rocks behind; and the far distance is the mountain range in the background.

ANALYSIS

When you've finished shooting the project, download your photographs to your computer so you can compare and contrast your results.

Above: The more three-dimensional a scene is (the greater the distance between the foreground and the background), the smaller the aperture needed to ensure adequate depth of field.

1 Either print out your images from the first part of the project, or view them one at a time on your computer monitor.

2 Carefully examine the image shot when the lens was set to its maximum aperture. Is the image critically sharp from the foreground through to the background? Note how much of the image is sharp and how much is unsharp. Work your way through the images, comparing them to see how the zone of sharpness from the foreground to the background changes as the aperture is changed.

3 Next, print out your images from the second part of the project and place them side-by-side or view them one at a time on your computer monitor. Look critically at the sharpness of your subject. It's very likely that the subject will not be sharp in the final image where you focused on the background, and the background will probably be unsharp when you focused on the subject. Which is preferable? Does it matter more that the background is unsharp or your subject? A compromise is often necessary if front-to-back sharpness isn't possible, particularly when using longer focal length lenses. Where the compromise is made is one of the decisions you may need to make when composing in future. Learning what is and what isn't acceptable is useful to know.

Left: Landscape images don't always need to be sharp all the way through. For this shot I used a wide aperture setting to minimize depth of field. Only the main subject (the stalk of grass on the left) is sharp. Minimizing depth of field for aesthetic reasons is more effective when shooting with a telephoto than with a wide-angle lens.

Above: There are numerous Smartphone apps that help you calculate the aperture and focus distance necessary to achieve the right depth of field for a successful shot (see the next page). An app was used to help make this shot, as it was critically important that front-to-back sharpness was achieved.

REFINE YOUR TECHNIQUE

When you are comfortable that you understand how aperture affects depth of field, consider taking your photography further by exploring the following options:

- Repeat the project using different focal lengths: what changes if you use a wider-angle lens, for example, or a telephoto focal length?

- The guesswork in achieving front-to-back sharpness can be removed by using the hyperfocal distance method, so search online for an app that will calculate hyperfocal distance for you and try using it "in the field" to maximize depth of field. However, you will need to judge visually how far you need to focus if your lens doesn't have a distance scale on it. If in doubt, use a slightly smaller aperture than that required by the hyperfocal distance method (if f/11 is required use f/14 or f/16, for example).

- With a short telephoto lens, experiment with shooting a close-up subject (such as the grass head on the page opposite). Shoot your subject using the full range of aperture setting to see what difference this makes

to the image. You should notice that depth of field is still relatively restricted, even when you are using the smallest available aperture. As depth of field is limited (particularly when using the widest aperture on the lens) you will need to think carefully about where you focus. Typically, you would focus on the most important part of your subject—the area of your subject that needs to be critically sharp.

Above: You don't need to use small apertures when scenes are essentially just background with no foreground or middle distance. For this shot the lens was focused at infinity and a moderate aperture of f/8 was used.

Above: The longer the focal length of the lens, the less inherent depth of field there is at a given aperture. This image—shot with a 50mm lens—required an aperture of f/22 to ensure front-to-back sharpness.

Right: If your close-up subject is moving (because of air currents, for example) you'll need to use a fast shutter speed in order to ensure that this movement is "frozen." This invariably means dealing with a very restricted depth of field (as you will need to use a large aperture, particularly if you don't want to increase the ISO too far). The solution is to embrace this restriction, focus precisely, and allow large (and unimportant) areas of the image to be out of focus. This technique can be used very successfully to simplify the background behind your subject.

IMAGE EDITING

If you're shooting JPEGs, there is generally no need to alter your images in postproduction—as long as you were careful with your settings at the time of shooting. However, using Raw will mean that an image will need some attention, even if it's just a quick polish to bring out its full potential.

SOFTWARE

Postproduction software is available to suit all skill levels and requirements. Both Windows and Mac OS X come with suitable software (Photo Gallery and iPhoto respectively) that allows you to make basic adjustments and organize your photos. Although these programs are free and easy to use, you will quickly find that they're limited in the features they offer.

Other free software to consider is that which came with your camera. If your camera shoots Raw, then it will come with Raw conversion software such as Digital Photo Professional (Canon) or Capture NX-D (Nikon). In terms of features, these programs are generally a significant

step-up from the software supplied with your computer's operating system.

However, while being able to adjust and refine your photos is important, there's more to good imaging software than that. Ideally, the software you use should also help you with Digital Asset Management (DAM). This is simply the ability to organize your photos in a logical, but straightforward way, through the creation of new folders and/or renaming of images.

Good DAM software should also allow you to add keywords to images. These are relevant, descriptive words (such as "landscape," "Rocky Mountains," "winter," and so on) that are attached to an image in its metadata, allowing you to search through your photographs to quickly find a particular shot. This may not seem necessary if you only have ten images, but it's vital if you have 10,000. Commercial image-editing software, such as Adobe Lightroom or Capture One Pro 7 produced by Phase One, feature very powerful DAM tools.

Left: Adobe Lightroom 5.5. At the time of writing this is the latest version of Lightroom.

Above: Atmospheric, high-contrast scenes are particularly suited to a black-and-white treatment. This image was originally shot in color and converted to black and white in postproduction. However, I knew at the time that it would suit conversion—switching to black and white shouldn't be seen as a way to rescue an otherwise weak image.

CONVERTING COLOR

The brightness or darkness of an object in a black-and-white photograph will depend on its reflectivity. If an object reflects an average amount of light back toward the camera then it will be a mid-gray in a basic black-and-white conversion. This can cause a fundamental problem, though. If two colored objects—a blue ball and a red ball, for example—have the same reflectivity, but different colors, they are easily distinguishable. However, convert an image of the two balls to black and white and they'll no longer be distinguishable—they will both be the same shade of gray as they reflect the same amount of light.

Fortunately, there's a solution, which is to use colored filters. A colored filter blocks the wavelengths of light on the opposite side of the standard color wheel to the filter's color. If you skip back to page 43 you will see that red is roughly opposite blue-green. The means that if you shoot a black-and-white image using a red filter, anything that is blue-green in the shot will darken, while anything that is red will appear slightly lighter.

Filters can therefore be used to change the tonal relationships of colored subjects in a scene. Although you could use filters over the lens, most cameras allow you to mimic the effects of a filter by selecting a color filter option

from the picture parameters. Raw conversion software will have similar ways to achieve the same effect, often in a subtler way, with greater control.

Above: Software such as Adobe Photoshop enables you to produce very precise black-and-white conversions. The color sliders allow you set how light or dark a pixel will be when it is converted to black and white—essentially replicating the way that colored filters over the lens work.

Left: These red, green, and blue patches are distinctly different in color, but as they have the same reflectivity, they are indistinguishable when the color is simply removed.

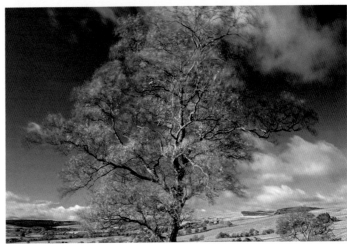

Above: Using colored filters (or their digital equivalent) can radically change how a black-and-white image is recorded. This color image (top left) was converted in postproduction using a blue filter (top right), a green filter (bottom left), and a red filter (bottom right). The blue filter has produced an unnatural effect with dense, dark foliage, and a weak sky. The result of using a green filter is pleasant, but the image lacks impact. The red filter is the most dramatic, with paler foliage, and a darker sky—this is my favorite, but it's a personal choice.

MONOCHROME

Aim: To convert a color image into black and white, using colored filters to control the process.

Learning objective: To see how color and filters affect the conversion of an image into black and white.

Equipment checklist:
• Camera and lens
• Red, orange, yellow, and green filters (optional)
• Tripod

Brief: You still need to think about color when shooting a black-and-white photograph, specifically how the various colors in the image will be converted into gray tones. This can be achieved by shooting in black and white in camera and physically fitting color filters over the lens, or by using digital, in-camera "color filters" (if available). A third option is to shoot in color and convert to black and white in postproduction. This will give you greater flexibility in the conversion process and is the recommended option for this project, particularly if you shoot Raw.

With your camera fitted to a tripod, shoot a landscape image that is rich in color. If possible, try to include readily identifiable colors such as red, green, and blue.

If you're shooting black and white in camera, select the Monochrome picture parameter and shoot one image without filtration. Then, either fit a yellow filter over the lens or select the yellow filter option from your camera's menu and take another shot. Change the yellow filter for an orange one (or select the orange filter option) and reshoot the image. Repeat this process using red and green filters (or their digital equivalent).

If you shot in color, import your image into your editing software. Most software has a simple desaturation tool, so apply this to your image so that all the color is removed. Export the file as a JPEG, giving it a unique name (making sure that you don't overwrite your original!).

Revert back to the original color file and use the black-and-white conversion tool in your editing software to convert the image to black and white again. Many programs have presets that mimic color filters (or color sliders), so use these to control the conversion. Experiment with the color sliders to see how they affect the tones in the image, then apply Yellow, Orange, Red, and Green filter effects (either by selecting the appropriate filter or by increasing the slider for the filter color you are trying to emulate). Export each image with a unique file name so you know which filter was applied to each black-and-white conversion.

Above: The use of a polarizer and a red filter has dramatically deepened the blue of this sky.

Right: Some scenes don't require the use of a colored filter. This coastal scene was relatively monochromatic already and so was converted without using filters.

ANALYSIS

Once you've converted your images to black and white, download them to your computer and take time to look at them critically (either on screen or as a series of prints).

Above: One of the benefits of applying filters in postproduction is that they can be applied selectively. For this shot I applied a red filter effect to the sky (to deepen the blue areas) and a blue filter to the foreground (to deepen the color of the red sand).

1 Return to the original color version of the image and think carefully about whether the image is more effective in color or in black and white. Not all images suit conversion to black and white, so one of the skills you need when shooting or converting an image to black and white is knowing which shots do and don't work.

2 Rank your black-and-white images in order of preference. Note the reasons why you prefer one image over another. Are there any images that you think don't work at all? If so, note the reasons why you think this is. Pay particular attention to the tonal range: is the tonal range wide, so the image looks full and interesting or does the tonal range appear compressed so that the various elements of the image appear to blend into each other?

3 Assuming you shot on a "blue sky" day, the red-filtered image should have a darker sky compared to the other images (red deepens blue tones more than yellow or orange). Red filters are often used to add drama to the sky in black-and-white images, but this can be overdone and not every image needs a dramatic sky. Green also darkens blue tones when they're converted to black and white, as well as lightening green foliage. Compare and contrast the red-filtered image with the green-filtered image: which one do you prefer, and why?

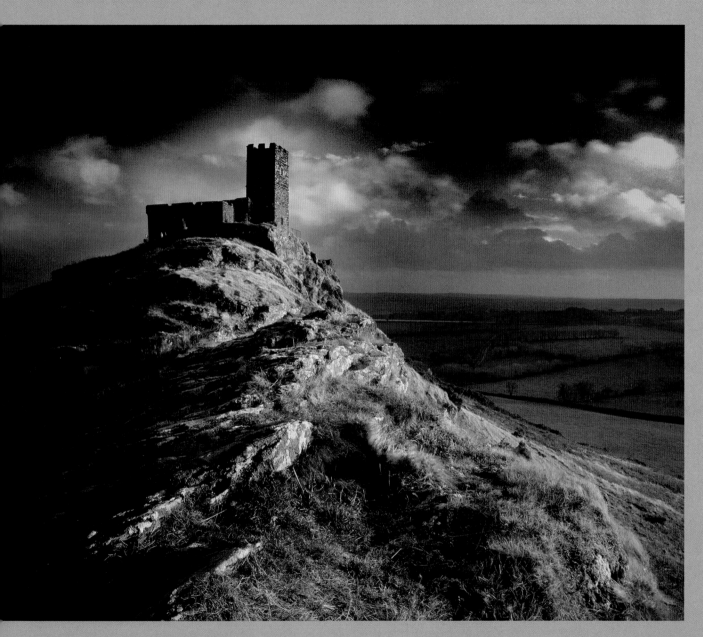

Above: This shot was made far moodier than the original by heavily darkening the sky and adding grain during postproduction. However, it's just one possible interpretation—there's no limit to the number of ways an image can be altered when converting to black and white.

REFINE YOUR TECHNIQUE

Creating a black-and-white image is about more than removing color: once you have mastered the basics, you can start to consider which subjects might work best in monochrome, and whether a color tint might enhance them.

- A black-and-white treatment produces images that are less literal than color photographs. This means that black and white arguably suits certain creative photographic effects better than color. A good example of this is using extended shutter speeds to shoot flowing water. In color, this effect will look decidedly unnatural and unrealistic if it is taken too far, but black and white is already "unrealistic," so there is less of a negative reaction.

- Black and white suits certain exposure techniques. Images that are predominantly light-toned (those with few tones, if any, that are darker than a midtone) are known as "high-key" images. High-key images feel light, airy and, with the right subject, romantic. Images that are mainly dark in tone (so have few, if any, highlights) are referred to as "low-key." Low-key images can feel oppressive, but also dramatic and striking.

- Just because you've converted an image to black and white doesn't mean you can't add color back into it. Tinting an image using a specific color can be very effective. The most common example of this is sepia— a reddish-brown color associated with 19th- and early 20th-century photography. However, a blue tint can also work well with landscape images, particularly moody landscapes showing stormy weather. Some cameras offer a small number of tinting options when shooting in black and white, but tinting can also be applied during postproduction, usually in a more controlled way.

Above: A dark, stormy evening is the ideal time to make a brooding, low-key image.

Left: A color tint can be used to convey physical temperature. The blue tint used here reflects the cold afternoon I spent making shots in this location.

PART TWO
LIGHT, COLOR & COMPOSITION

To make a photograph you need light—without light you wouldn't be able to make an exposure, no matter how long the shutter was held open for. However, there's more to making an interesting image than the presence (or otherwise) of light. Light has many qualities, such as hardness and direction, and understanding how these qualities affect the way your subject is recorded will play a key part in your final image.

Another factor in making a successful photo is how you arrange your subject (or subjects) within the boundaries of the image frame. This is known as composing a shot. There are certain compositional "rules" that can be applied to image making, but these don't need to be strictly followed. In fact, it's arguable that creative photography is about knowing when to break these rules as much as it is about following them.

Left: This photo breaks the commonly practiced "rules" of photography, but I still think it works. Do you?

Far left: Although this may look like a black-and-white photograph, it is actually a color image. I took the shot into the light on a slightly hazy day, which has leeched the color out of the scene and emphasized the graphic nature of the composition.

LIGHT PROPERTIES

It may seem to be stating the obvious, but you need light to make a photograph. However, light can have many qualities, and to progress as a landscape photographer you need to understand how these qualities affect your images.

WHAT IS LIGHT?

Visible white light is actually a range of wavelengths that start at approximately 700 nanometers (nm), corresponding to the color we perceive as red, and end at 390nm, which corresponds to violet. When sunlight is refracted through drops of rain a rainbow is formed. The spectrum of colors in a rainbow—from red through to violet—neatly demonstrates the order of the wavelengths (and corresponding colors) that make up visible light. This order can also be seen in a standard color wheel (see page 43).

Light is pure white when there is no bias of one wavelength over another. However, if part of the spectrum of wavelengths is blocked, then the light will no longer be neutral—it will be biased toward the wavelengths that are not blocked. This is why in-camera white balance is necessary, as it neutralizes this bias when it occurs.

The sun's light is theoretically neutral. However, because the blue-violet wavelengths of light are shorter than red they are more readily blocked by dust or particles in the earth's atmosphere. This occurs when the sun is low on the horizon at sunrise or sunset (the light from the sun passes through a thicker slice of the atmosphere than it does during the middle of the day). Consequently, at either end of the day the blue wavelengths of light are scattered and absorbed, and the sun's light is very heavily biased toward the longer red-orange wavelengths of light.

Left: Rainbows only happen when the sun is relatively low to the horizon. This is why you will never see a rainbow at midday during the summer.

Right: Shot a few hours before sunset, the light in this image is far warmer than it was at midday. The light is at its warmest close to sunset.

WEATHER & LIGHT

If the sky were perfectly clear, with no dust in the atmosphere or clouds, there would be little variation in the quality of the sun's light from day to day. This would be incredibly monotonous for landscape photographers!

Fortunately, weather alters the quality of sunlight, making our photographic life more interesting. As already mentioned, complete cloud cover will soften sunlight considerably, but even partial cloud will help to soften the sun's light by bouncing reflected sunlight into shadows in the landscape, making the shadows less dark and dense.

Pre-sunrise or post-sunset clouds will also reflect the light of the sun back down onto the landscape—even though the sun is below the horizon. At these times of day the sun's light is very red, so the clouds and the landscape are both very warm in tone.

Hazy conditions—seen particularly strongly after a few days of settled weather—will also soften sunlight,

although to a lesser degree than clouds will. However, too much haze isn't ideal as it reduces both visibility and the vividness of distant details.

There's rarely any drama to a day with clear blue skies and sunshine from dawn to dusk. Ultimately, it's those days when the weather is changeable that are most exciting to landscape photographers, although there's a good chance that you'll get wet and cold in the process. Wind can also be stronger making it more difficult to keep your camera steady. However, these are minor inconveniences that can be resolved quite easily, and they're generally forgotten when nature puts on a light show that makes it a great photograph—at that moment it's all worthwhile.

Below: The further away something is from the camera, the more that its color saturation, contrast, and sharpness are reduced. This effect is known as "aerial perspective" and it helps to convey a sense of depth in an image. Haze exaggerates the effect to an unacceptable degree—this image was shot on a relatively clear day close to sunset and the effect is just right.

Above: This shot was taken late in the afternoon after a day of pleasant weather that wasn't inspiring photographically. However, those clouds represented a wet weather front that was advancing toward my location. I had one hour of very productive shooting before the weather finally turned and I had to give up for the night.

SHOOTING THROUGH THE DAY

Aim: Take a series of images of the same scene over the course of a single day.

Learning objective: To see how the color of daylight changes throughout the day.

Equipment checklist:
- Camera and prime lens (or a zoom lens set to a single focal length)
- Lens hood
- Tripod and remote release
- A watch or smartphone to keep track of time
- Filters (optional)

Brief: Shoot a sequence of six to eight images from the same location over the course of a day, using exactly the same composition each time. This will require the use of a tripod. If you can keep your tripod set up all day in one position that would be ideal. If not, choose a location close to home so you can easily revisit it during the day.

Switch you camera to Aperture Priority and set an aperture sufficient to achieve the desired level of sharpness in your image. Use a fixed ISO—ideally the lowest setting available to maximize image quality—and don't alter the aperture during the course of the day. The camera will automatically set the shutter speed for you, which is another good reason to use a tripod (the shots toward the ends of the day may have lengthy shutter speeds when the light levels are low).

To keep depth of field consistent, focus manually for the first shot and then leave the focus for the other shots in the sequence (be careful not to knock the focus ring during the day).

Left: Shooting in the late afternoon in summer produces images with a cool color palette. I could have added warmth by adjusting the white balance of this shot, but this would have had an adverse and unnatural effect on the sky.

TIPS

- Shoot on a day that's likely to see reasonably settled weather, with periods of sunshine from dawn to dusk.

- If you can't leave your camera set up all day, make a print of the first image you shoot so that it's easier to set up the composition again.

- If you point your camera north you will be less likely to have the sun shining directly toward it at any point during the day.

- Choose a location that's likely to be illuminated by the sun over the course of the day. Don't shoot at the bottom of a deep valley or in woodland!

Finally, set the Daylight white balance preset. This is simply because you will not see the effects of any changes in the light in your images if the camera is set to Auto white balance.

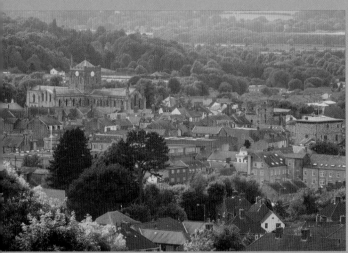

Start shooting at sunrise and continue on to sunset (if you're shooting in an urban environment you could even shoot a final image at dusk). Try to space your shots out equally during the day—at hourly intervals, perhaps—and make a note of where the sun is relative to the camera when you shoot (is it to the left, above, right, and so on).

Above: This sequence of four images was shot over the course of a single day: early morning (top left), late morning (top right), late afternoon (bottom left), and evening (bottom right). You can see a later shot, taken after dusk, on page 74. The composition is exactly the same, as the camera was left mounted on a tripod in the same position all day, and the white balance was set to the Daylight preset. Consequently, only changes in the lighting affect the mood between shots. Which one do you prefer?

ANALYSIS

Once you've shot your sequence of images, download them to your computer, print them out, and lay them on a table in chronological order. If you don't have a printer, try viewing them as a slideshow on your computer.

Above: Revisiting a location frequently will help you to appreciate how much variability in the quality of light there can be.

Above: Weather can make a big difference to the quality of the light. A thin slit in the cloud layer focused early-morning light dramatically across this valley landscape.

1 Look at each shot, paying particular attention to the quality of the light—its hardness or softness, its direction relative to the camera, and whether it appears warm or cool. Once you've done this, rearrange the prints in order of preference—is the image order the same as before, or has it changed?

2 If the order has changed, what are the factors that have prompted the change? Is it the lighting direction or the color of the light? Would the images that are less preferable have been improved by a different viewpoint (so that the lighting direction changed relative to the camera)?

3 If the order hasn't changed it's equally useful to consider why not. This could be because you chose a position where the lighting was sympathetic to the scene throughout the day. This is more likely during the winter months when the sun doesn't travel as far across the sky as it does in summer (and the light is "warmer" for longer during the day). If you shot the scene in winter try to visualize where the sun would rise and set during the summer months and how it would arc higher across the sky. Would your photo sequence work as well during that season?

4 Shadows help to define a sense of three dimensions in an image. Which of the images in the sequence look the most three-dimensional? Where was the sun relative to the camera for the shot? Which of the images looks the least three-dimensional? Again, assess where the sun was relative to the camera when making your decision.

Above: Don't stop shooting just because the sun has set. With the right subject, the soft light of dusk can be just as appealing as a dramatic sunset.

Left: The side lighting in this shot has helped to define the shape of the individual stones in the wall. Frontal lighting would have been less effective and produced a flatter-looking image.

REFINE YOUR TECHNIQUE

This project should give you an appreciation of how light changes over the course of a day. However, the light will also change depending on the weather conditions and with the seasons, so there are plenty of opportunities to expand your knowledge and skills.

- It is worth repeating this project again on a day with more variable weather—on an overcast day the changes will be subtle, while choosing a day when the weather changes dramatically will also deliver different results.

long-term project you could try shooting a single image at another location once a month over the course of a year. To do this you will need to think more carefully about your subject, as only south-facing subjects will receive light all through the year. North-facing subjects will be less appropriate as they won't receive direct light during the winter months. It's also worth choosing a subject that will show a marked seasonal variation. Deciduous trees will change dramatically over the year, whereas something like a rocky outcrop will not.

Above: Some locations you may see only once in your life (on a once-in-a-lifetime vacation perhaps). To do justice to those locations it pays to prepare in advance and find out as much as you can about them. This location, far from my home, was discovered by looking at maps and tourist information web sites before beginning my travels.

Right: Soft light suits softer, organic subjects such as these flowers. Although cloudy, the sky still retains texture and form, and so was included in the composition. If the cloud had been more uniform I would have been more inclined to exclude it.

COLOR PROPERTIES

Colors have a strong effect on our emotions. An understanding of these effects will help you give your landscapes more impact.

RED, GREEN, AND BLUE

The individual pixels in a digital image are created by blending red, green, and blue in varying proportions. This is even the case with black-and-white images—gray pixels are an equal mix of red, green, and blue; black is a complete absence of red, green, and blue; white is created by setting those colors to their maximum values.

Red, green, and blue are primary colors, so-called because all of the other available colors in a digital image are ultimately derived from them. If you mix any two at their maximum value, you produce a secondary color, as shown in the illustration below left: green and blue produce cyan; red and green produce yellow; and red and blue produce magenta. All three colors together give white.

A color has three basic qualities: hue, saturation, and value. Hue is essentially another word for color: red, green, and blue are all hues, as are yellow, cyan, and magenta.

Saturation describes a color's intensity or vibrancy. A vibrant color is one that has no black, white, or gray mixed into it—primary and secondary colors are all highly saturated. Colors that are highly saturated are inherently more eye-catching than those that aren't, but highly saturated colors aren't particularly natural-looking. Image-editing software generally allows you to increase the saturation of the colors in an image, but it's all too easy to make the image appear garish as a result.

Finally, value describes the lightness or darkness of a color. The higher the lightness value, the closer that color is to white; the lower the lightness value, the closer it is to black. Bright, higher value colors tend to stand out more than darker, lower value ones.

Left: When two of the primary colors—red, green, and blue—are combined they produce a secondary color. All of these colors are highly saturated.

Right: Nature rarely produces heavily saturated colors, even at colorful times of the day such as early morning.

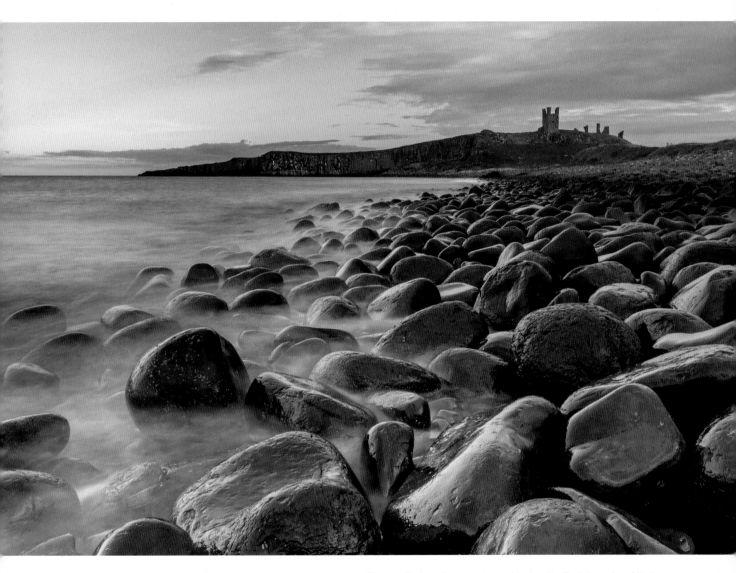

Above: Dark and wet or glossy objects will reflect the color of their surroundings. There is no direct light on the wet rocks in the foreground of this photograph, but they have a heavy blue tint as they are reflecting the color of the sky above.

USING WHITE BALANCE

Aim: Take a series of images under different weather conditions, using a variety of white balance settings.

Learning objective: To explore how white balance can both neutralize and alter the color in an image.

Equipment checklist:
- Camera and lens
- Tripod and remote release
- Filters (optional)

Brief: The color of the light from the sun is affected by its height in the sky and by the weather. White balance allows you to compensate for or exaggerate this color variation. For this project, shoot two sets of images in the same location: one set on a sunny day and the second set on an overcast day. Shoot at least one hour after sunrise or before sunset so that the light levels and color temperature of the light are reasonably constant.

On both sessions mount your camera on a tripod so that the composition is fixed. Set the camera to the Auto WB preset and shoot an image. Then work your way through the other presets in the order shown on your camera's WB menu (see page 43 for a guide to the presets), shooting an image for each preset. You could also try creating a custom white balance by using a sheet of white card as described on page 44.

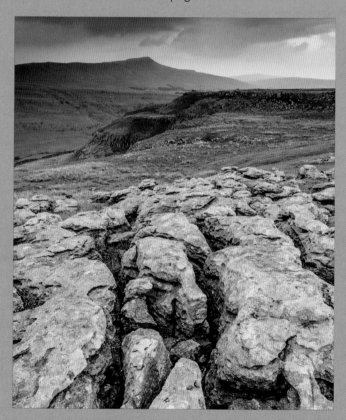

Above & Right: The white balance setting you use can alter an image quite radically. The main image (right) was shot using a Daylight white balance, while the smaller image (above) was taken with the white balance set to Shade. To me, the main image is more realistic (and reflects what I remember of the scene itself), while the smaller image is a touch too warm. However, you may have a different opinion!

TIPS

- If you're shooting Raw you can shoot one image for each session and adjust the white balance in postproduction.

- WB is fixed if you shoot JPEG and is harder to adjust later without a loss of image quality.

- Changing the white balance has no effect on exposure—the exposure should remain constant from the first image shot to the last.

- You may need to use an ND graduated filter to hold detail in the sky, particularly during the overcast session.

- The white balance settings used at the time of exposure are viewable in image playback on your camera. Postproduction software will also show the white balance setting.

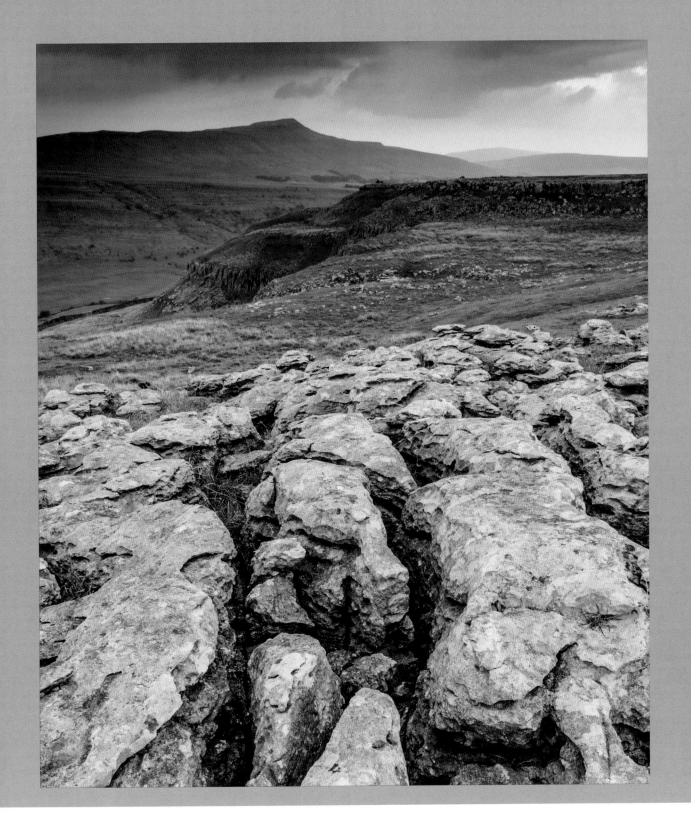

ANALYSIS

Once you've shot your sequences of images from both sessions, download them to your computer and either print them out or open them on screen so you can view and assess them individually in the order that you shot them.

Above: Light at the middle of a cloudless day is relatively neutral (more so in summer than in winter). Warming up an image shot at midday can make grass appear insipidly yellow and unnatural. It can also make skin tones (if you've people in your shots) look slightly jaundiced too.

1 Start by viewing the images from the first session, before moving onto the images from the second session. If you shot using Raw, set the white balance in your postproduction software to alter the color of your image before printing it out.

2 The first image should be the one that you shot (or converted) using Auto WB. View it critically for colour accuracy in terms of how you remember the scene. If it doesn't match your memory assess whether Auto WB has produced a pleasing image or not. Auto WB is a powerful camera function, but it can be fooled—sometimes in a pleasing way, sometimes not. Getting to know which situations your camera's Auto WB is likely to struggle with is important knowledge.

3 Assess the other images in the sequence, not only in terms of color accuracy, but also aesthetic appeal—the two aren't necessarily the same. Pay particular attention to the images shot using the Daylight and Cloudy presets. Is the image shot on a sunny day more pleasing when the WB was set to Daylight or Cloudy? Is the image shot on an overcast day more pleasing when the WB was set to Daylight or Cloudy? Note how warm or cool the images are.

4 The images shot using the Incandescent and Shade presets will be most affected in terms of color. It is likely that they will be very cool blue and very warm orange respectively. Although it may not be "natural," it may suit your images, so think about how you could use this in the future to add impact to an image.

Left: A camera's white balance presets are a blunt instrument. When shooting Raw you can fine tune the white balance very precisely. This image was set to a Kelvin value of 4900 to stop the reds becoming too "hot" and to maintain the vibrancy of the blues.

REFINE YOUR TECHNIQUE

There are countless ways that you can explore color in your images using your camera's white balance control: from attempting to get it as accurate as possible or using color creatively to alter how your images "feel."

- White balance is very effective at neutralizing the color bias of a light source. However, the "correct" white balance isn't necessarily right for an image. Adjusting the white balance to an "incorrect" setting—either during postproduction if you're shooting Raw or in-camera when shooting JPEGs—is a powerful way of affecting the overall mood of a shot. To extend this project try experimenting with "incorrect" white settings (use the Cloudy preset when shooting in sunny conditions, for example). Assess the impact this has on your images and show them to friends and family to get their feedback.

- How you set the white balance is as creative a part of photography as composition or exposure. Colors are frequently associated with emotions in everyday sayings, such as "seeing red" and being "green with envy." The white balance you choose can also affect the emotional reaction people have to your images. Cool blue images have a more calming, tranquil effect than warmer colors such as red, which are associated with energy and vibrancy. Using the "wrong" white balance can therefore alter the emotional impact of an image.

- Warm colors, such as orange and red are associated with higher physical temperatures, and cooler colors (especially blue) with lower, colder temperatures—you're never "red with cold!" Setting an appropriate white balance is a very effective way of conveying temperature in an image too.

Above: Deliberately using a cool blue (and technically "incorrect") WB setting is very effective when shooting seascapes on overcast days.

Right: Shadows are very blue as they are lit by ambient light from above, which is generally the sky. Whether you correct for this coolness or set white balance to retain the blue color (as here) is an aesthetic choice.

RULES OF COMPOSITION

Composition is the art of arranging the various elements in a photograph in a pleasing or thought-provoking way. This is the one aspect of photography that is very much in your hands, although there are certain "rules" that can be used as a starting point.

THE RULE OF THIRDS

This is probably the most widely recognized and used of all of the compositional rules. There's no denying that the rule works, and using it is an excellent shortcut to producing a pleasing image. However, it's not particularly creative to reuse the same approach over and over again.

The idea behind the Rule of Thirds is simple. You divide an image up into nine equal rectangles, using two vertical lines and two horizontal lines (as illustrated at the right). Important elements in the scene—such as the horizon—are then aligned along one of the grid lines or, if the subject is smaller, placed at one of the intersection points of two of the grid lines.

Many cameras can display a Rule of Thirds grid over the LCD screen in Live View mode to make it even easier to apply the rule.

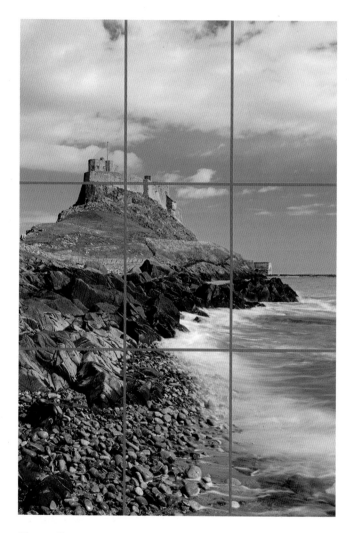

Above: For this image, the castle on the hill was placed at an intersection of the thirds lines.

Right: This image "breaks" several rules. It is not composed using the Rule of Thirds or the Rule of Odds (described on page 99). However, sometimes you have to break the rules if it serves your vision for a photo.

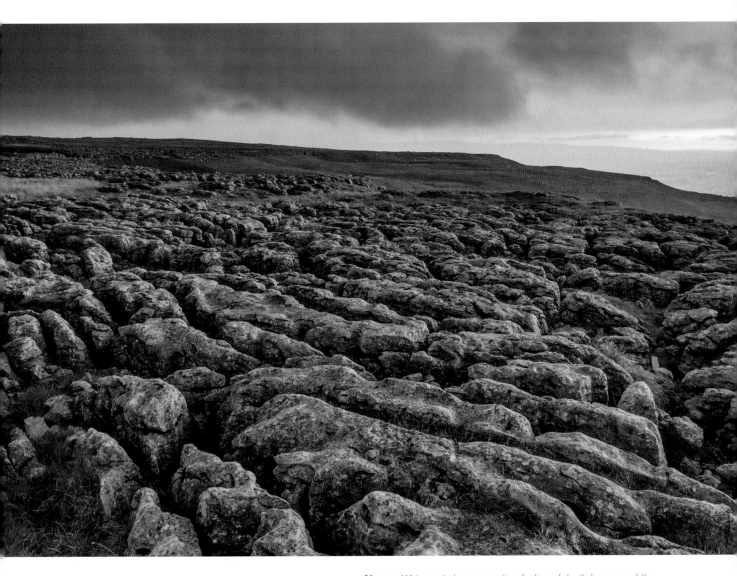

Above: Wide-angle lenses create a feeling of depth because of the way in which details in the landscape appear to recede quickly into the distance.

LINES

Including a line running through an image into the far distance immediately adds depth to that image. This is strengthened if there is a series of lines that dynamically converge, which is most often seen and enhanced when using wide-angle lenses.

Lines are also a very powerful way to guide the viewer to the subject of the image, but they can also lead the eye away from the subject or even out of the image altogether! For this reason, lines should be used with care.

Lines can either be a permanent part of the landscape—a path or track for example—or they can be fleeting, such as clouds or the line of a wave breaking. They can also be implied by the way you position your camera so that different elements in the picture line up.

Lines can be straight or curved. Straight lines lead the eye on a shorter, more direct, and therefore "faster" journey through the picture space. Curved lines, by their very nature, are more meandering. This makes them slightly more interesting and increases the time that it takes to appreciate an image.

Below: Our eyes naturally follow lines through an image. Which way did you work your way through this rural photograph?

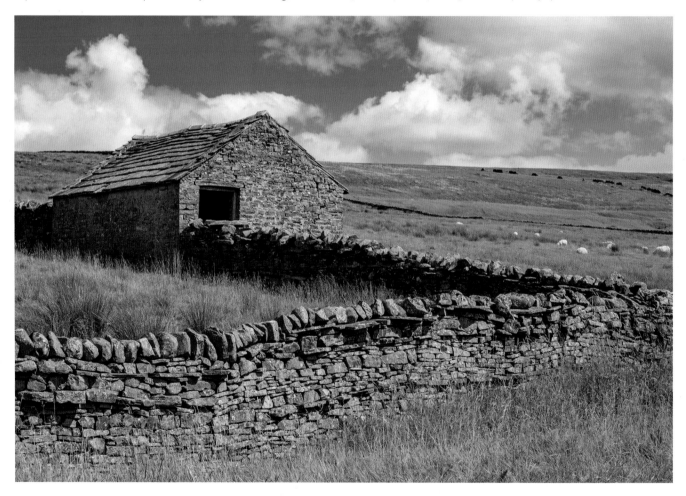

Left: Lines don't have to be a permanent part of the landscape—they can be as fleeting as a wave washing up on a beach.

Below: The striking converging lines of these shadows were exaggerated through the use of a wide-angle lens and by setting my camera low to the ground.

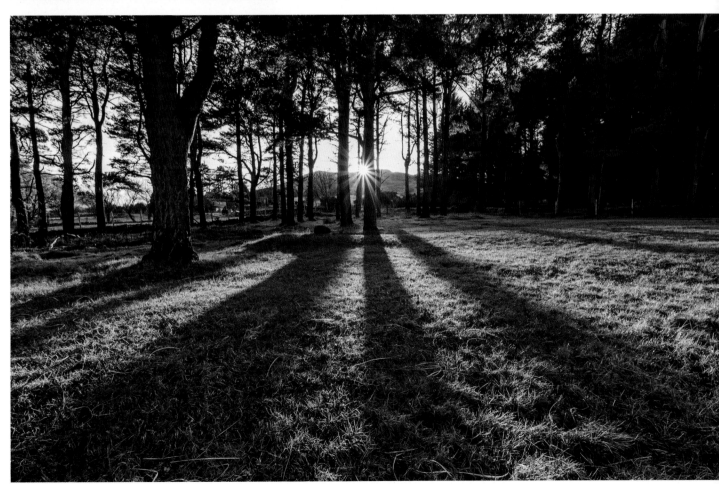

SIMPLIFYING

Composing a photograph is as much about deciding what to exclude as what should be included. When faced with a stunning scene it's tempting to try and include as much as you possibly can, but this can lead to very cluttered and confusing images with little coherence.

When you compose a shot you are telling a story about a place, and like all good stories it should have a clear narrative. You therefore need to think carefully about what your subject is. Then, think about what will enhance your subject—by leading your eye through the image space to the subject or giving it a context. Finally, think about what will detract from your subject.

The latter is what you should be striving to exclude, and this can be achieved by altering your position relative to your subject—moving slightly left or right, forward or backward can make a huge difference to a composition. It can also be achieved by your choice of lens. It often takes more thought and time to compose with a wide-angle lens, as more of a scene is included in the image space.

Left: On either side of this shot the sand had been disturbed by people and animals walking around. However, by composing the shot vertically and choosing a viewpoint carefully I was able to show a pristine landscape free of distracting detail—including the footprints would have told a different story entirely.

ABSTRACTION

You don't always need to create images that tell a literal story of a place: by concentrating on shape, pattern, or texture you can create pleasing abstract images that defy immediate interpretation.

This type of image is easier to achieve with a telephoto lens, as wide-angle lenses generally produce images that are too information-rich, unless you're able to get particularly close to your subject. Abstracts can be relatively formless, so there is no pattern for the eye to follow, or you could arrange your shot so that lines or patterns direct the eye around the image space.

Below: This abstract shot was created by zooming in tightly with a telephoto lens on the sunset light reflecting off wet sand on a beach.

USING FOCAL POINTS

Aim: Take a series of nine images utilizing different compositional approaches.

Learning objective: To discover how the position of the focal point affects composition and the "visual journey."

Equipment checklist:
• Camera and standard focal length lens (zoom or prime)
• Tripod
• Filters (optional)

Brief: The focal point of an image is the central point of interest. Not every image needs a particular focal point, but if it does have one, a photograph is inherently more interesting if the eye can be taken on a visual "journey" to this point.

For this project, shoot a series of nine images based around the same focal point (such as a lone tree or an interesting rock). Position the focal point as follows:

1 Using the Rule of Thirds.
2 To create a visual balance.
3 To create a visual imbalance.
4 According to the Golden Triangle.
5 With the camera in a horizontal orientation.
6 With the camera in a vertical orientation.
7 With the focal point low in the frame.
8 With the focal point high in the frame.
9 Finally, create an image that "breaks the rules." This could be done by placing the focal point at the edge of the frame, or centrally in the shot, for example.

TIPS

• Try to simplify your images as much as possible. Too many elements will make it hard to work out what the focal point of your shot is.

• Subjects with a heavy visual weight make good focal points.

• Dark subjects (or those in shadow) will make less strong focal points than brighter subjects.

Above: The focal point of this shot is the bug. The red markings help draw the eye directly to it, as do the main veins of the leaf.

Right: The focal point in this shot is the sycamore tree. The grasses, pointing upward from the bottom of the frame, help to draw the eye through the shot.

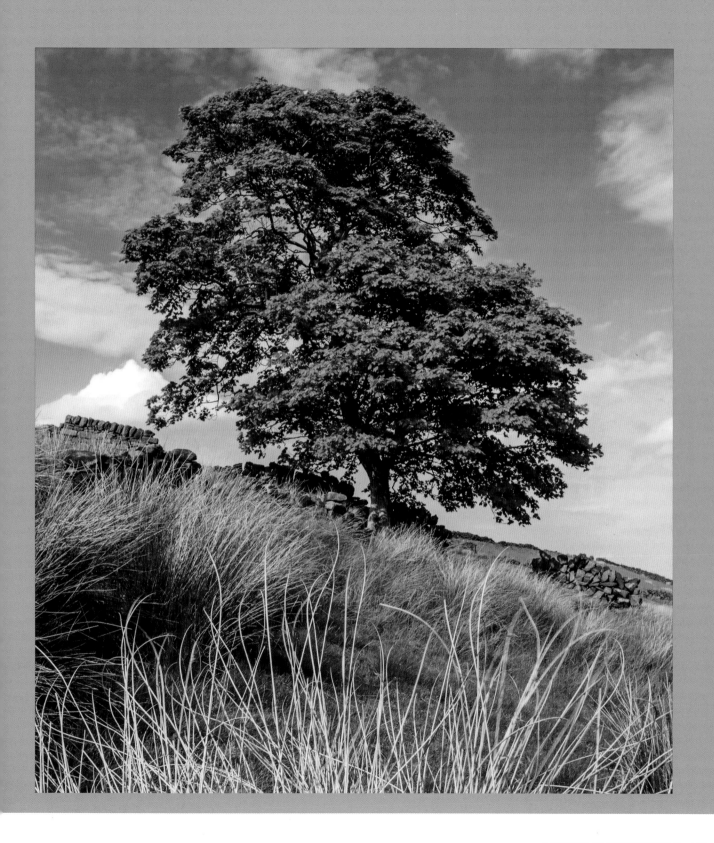

ANALYSIS

Once you have completed the project, download your images to your computer and either review your pictures on screen, or print them out so you can assess them. You may find that asking friends or family for their feedback is also a good idea.

Above: An image filled with detail, such as this flower-filled field, will be confusing to look at. The solution here was to use a wide aperture to throw the background (and most of the confusing detail) out of focus.

Above: An image without a focal point doesn't have a natural place for the eye to rest.

1 Study your images in turn, paying particular attention to the journey your eye takes through the image and where the destination is within each of them. Is the natural destination in each image the focal point you originally intended? If not, note what elements in the images have caused your eye to wander. Dominant colors such as red or patches of white can be very distracting, particularly if your intended focal points are relatively subdued in color or are darker than their surroundings.

2 If you find it hard to be objective when assessing the composition of your images try rotating them by 180°. Looking at an image upside down is a surprisingly useful way to assess the merits of a composition: you're able to look at an image more objectively as a series of shapes, colors, and lines than when it's the right way up.

3 As you analyze your images ask yourself if there are elements in the pictures that are there unexpectedly—elements that you don't remember seeing when you originally composed the image. If so, could this be because your viewfinder doesn't provide 100% coverage of the scene? Would using Live View remedy this?

4 Summarize your conclusions for each image. Any notes you make should be as objective as possible—it takes time to get a feel for composition, so be fair to yourself. Note down what works in each image, as well as what doesn't. Consider repeating this project using your notes as a guide.

Left: Lines that lead your eye to a focal point don't need to be permanent. The borders of these puddles of water create interesting lines, but they didn't last long— just one hour later they were gone.

REFINE YOUR TECHNIQUE

This project is all about placing your subject in the frame, and there's no single right or wrong answer. Consequently, this is a project that you can attempt multiple times, with a variety of subjects, to expand your compositional skills.

- Although using Live View to compose your shot will show you 100% of what the sensor will record, it can sometimes prove problematic. This is because camera manufacturers like to cram as many icons and as much shooting information onto the LCD screen as possible. This information is useful, but it can be distracting, and it can also hide important features of the landscape that you may or may not want in your shot. If you are using Live View it is important to turn all this information off when framing your shots, so you can see the entire scene that will be recorded. Only turn it back on again when your shot is set up and you need confirmation of the current camera settings.

- Think back to when you composed the images for this project. Did you look around the entire image or did you concentrate just at the focal point? Looking at one area of the image when composing is a common mistake. It's important to run your eye around the entire image, looking for anything that could detract from the image as a whole.

- An optical viewfinder should ideally show you a 100% view, but not all cameras do this. Some only show 98% or even only 95% of the scene the camera will record. If you're using a zoom lens you can compensate for this by zooming out slightly. Check the edges of the frame to make sure that nothing distracting is intruding into the picture space, and then zoom back in to reframe the image as you originally intended.

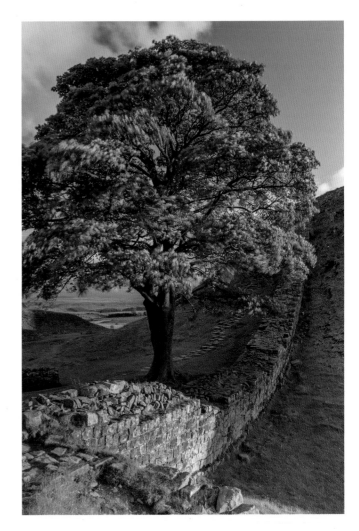

Above: A common mistake is to crop in too tightly on a subject. It's a mistake I made with this image. The tree feels squashed into to the frame, with little room to "breathe." On reflection, I should have pulled back and included more of the surrounding environment.

Left: Words, signs, and symbols (such as arrows) are visually very heavy. Only include them if they're an important part of the composition.

Above: Compact cameras are ideal for taking out on a non-photographic day trip (it's frustrating to not have a camera if you see something of interest). Compact cameras tend to feature LCD screens that are busy with icons. As this is your primary way of composing, it is better to switch all this visual clutter.

PART THREE
ON LOCATION

Above: Part of the pleasure of landscape photography is the excuse to be outdoors. I always try to get to a location in good time so that I'm not stressed and can savor the moment.

Ultimately, landscape photography is all about getting outdoors and shooting pictures. One of the wonderful things about photography is that you bring your own background and interests to the subjects you prefer to shoot. Landscape photography is no different. It may be large, open vistas that inspire you to create images, or it may be more intimate, close-up scenes that excite you—there's no right or wrong answer to what you choose to shoot.

This, the final part of the book, covers some of the landscape subjects you could consider shooting. It also explores some of the potential problems that you might encounter along the way—as well as the solutions!

Below: I find the challenge of working in low light very rewarding. It almost makes winter in the United Kingdom (and the resulting long nights) something to look forward to!

LANDSCAPES

In this lesson, "landscape" is taken specifically to mean locations inland from the sea. This takes in a wide range of different types of scene, each of which has its own challenges and rewards.

MOORLAND, HILLS & MOUNTAINS

These three types of landscape are probably the most physically challenging to photograph. Because of the time it takes to reach a suitable location it's often a good idea to camp close to your location the night before—particularly if you want to shoot at sunrise (the alternative is to navigate in the dark, which is only recommended if you're following a well-trodden path).

Being high on a hill at sunrise has several advantages. For a start, the peaks of hills and mountains are lit long before any valley (and if the hills or mountains are high enough, the valley may not even see direct sunlight during the winter months).

Another advantage to being at a higher altitude comes during a temperature inversion. This happens when the temperature *increases* with altitude, rather than decreasing. During a temperature inversion the clouds will be lower than normal, so if you're high enough, you will be above the cloud layer.

The challenge with moorland is bleakness. Moorland is often relatively empty, with few trees and low, ground-hugging plants. The key here is to use any points of interest you can find, whether those are rocks, bushes, or streams. Summer and fall are good times to be out shooting on moorland: heather moorland is a riot of color in late summer, while fall sees grasses turn golden brown.

Below: This sunset shot of a hilltop on the border between England and Scotland required walking back in the dark. In this situation a head-torch is invaluable, as it keeps your hands free.

Right: Undulating landscapes take their toll on your knees. Walking poles are a useful addition to your kit, and some can even be turned into a very handy monopod.

SNOW & ICE

As with working in a desert, there is a physical challenge to be overcome when working in a wintry, snow-covered landscape: this time it's cold. Landscape photography often involves standing around waiting for the right light, and when working in wintry conditions you can easily get dangerously cold (particularly if you worked up a sweat getting to your chosen location).

Wearing the appropriate clothing is therefore key. Your feet, being in contact with the cold ground, are particularly vulnerable, so good boots and thick socks are vital. Your outer garments should be windproof to help reduce the effects of windchill. Below this wear layers of warm clothing to trap warm air close to your body.

Gloves are essential, but they can also make it difficult to use your camera's controls. Fingerless gloves are one solution, but I prefer to wear two pairs of gloves— a thick pair of outer gloves and a less substantial inner pair. When using the camera the outer pair can be removed.

TIPS

- Brush off any snow that falls on your camera before it starts to melt.

- Any color in the foreground of your shot will have more impact if it is surrounded by snow.

Below: Clouds help to "bounce" light back into the shadows, reducing the high contrast that is often found in snow scenes.

LOCATION SCOUTING

Aim: To find two locations with the potential for shooting at specific times of the day.

Learning objective: To understand the importance of researching and planning a location visit.

Equipment checklist:
• Camera and lenses
• Tripod
• Filters (optional)

Brief: Planning is a vital part of being a landscape photographer. For this project choose two locations that you can reach easily, but that you are relatively unfamiliar with. The first location should be chosen for its potential at sunrise, and the second for its potential at sunset.

Use maps as well as resources such as the Internet to help visualize the terrain you will encounter and the location of any potential subjects. Think carefully about where the sun will rise or set and how this may affect the way in which potential subjects will be lit. Shoot at least five different shots at each location.

Once you've visited both locations repeat the exercise, this time visiting the "sunrise" location at sunset and the "sunset" location at sunrise.

TIPS

• Use maps to work out where the sun will either rise or set during your photography session.

• Factor in how long it will take you to reach your location.

• Check the weather forecast the day before your session. If the weather isn't suitable, reschedule your trip.

• If you are making an early start, pack everything you need the night before to save time.

• Tell a family member of your intended destination and when you'll be returning.

Left: Although planning is very important, chance should also be allowed to play a part. This image was shot walking on a path on the way back from an afternoon shooting. It turned out to be my favorite shot of the day.

Right: I visited this location in the English Lake District after working out what would be there when I arrived, what time sunrise was, and how long it would take me to reach the location.

ANALYSIS

As with previous projects, it is important that you analyze the results of your shoot so you can determine what works and what doesn't. Start by downloading your images from your camera's memory card and either print them out or view them on screen.

Above: Knowing when and where the sun rose was an important part of planning this shot. As it was summer, it meant a very early start, so a mistake would have been unacceptable.

1 View your images once you've been on your photographic expeditions. Look at them critically to see how closely your experience of the locations matched your expectations in terms of what you could see, the terrain, and the surrounding geographical features (do not worry about anything intangible, such as the weather). If the experience wasn't what you had hoped for, why was that? Work through your original planning methods to try and establish where errors could have occurred.

2 A common mistake that all landscape photographers make at some point in their career is forgetting to check the height of nearby geographical features and how they will affect the time the sun first appears or disappears. Sunrise and sunset times are calculated on the assumption that you're standing at sea level, with nothing between you and the horizon. In hilly terrain this means that the sun will appear to rise much later or set much earlier than the sunrise or sunset times would suggest.

3 Compare the sunrise and sunset images from the first part of the project with the images you took for the second. Note whether the change in the time of day made a difference to what it was possible to shoot successfully. Was this surprising or did you feel your initial research was an accurate assessment of the potential for the locations?

4 Use your experience with this project to plan a shoot at a different location. Repeat the project, paying particular attention to those areas of your planning that you felt were weakest the first time.

Left: As much as it's important to plan, you should always leave room for the unexpected. The effects of this weather front weren't something I'd planned for (other than packing waterproof clothing). However, I made the most of the opportunity when it arose.

REFINE YOUR TECHNIQUE

Some locations will naturally be more photogenic than others, but even the same location can be transformed depending on the time of day (or year) you visit it, making thorough research an essential part of the process.

- To get to your chosen location often requires physical effort (not forgetting that you have to get back to safety once you're finished with the photography), so landscape photographers need to have a good level of fitness. This comes very quickly with regular photography sessions, particularly as you'll be carrying heavy equipment. Getting to a location also often requires a degree of navigation, particularly if you leave regularly walked footpaths. For this reason it's worth taking time to brush up on your navigation skills—even to the extent of going on a course at a local college. No photograph is worth taking an unnecessary risk for.

- Snow-covered landscapes are generally best tackled early in the morning—it's frustrating to arrive too late and discover your pristine snowscape is covered in footprints! Snow is highly reflective and so can fool camera meters, causing them to underexpose your images. Either take a spotmeter reading from a midtone area in the landscape (such as a rock poking out of the snow) or apply +1½ stops of positive exposure compensation as a starting point. If the sky is blue, the shadows in the landscape will also be blue, but this can be compensated for with a custom white balance—use a patch of snow in direct sunlight (not one that's in shadow) to create the custom setting.

- One difficulty with photographing deserts is conveying a sense of scale. People, particularly if they're relatively small in the frame, will help to show the vastness of the desert, and adding a person (or animal) will also help to tell a story about life in the desert. Failing that, look for points of interest that can be added to your images: rocks or plants work well.

- When researching sunrise or sunset times, make sure they've been corrected for any daylight saving times in force that day. If you use your cellphone as an alarm clock, ensure that the time on that is correct too. Modern cellphones will update automatically when the clocks change, but older ones may not.

Left: No matter how well you plan there will still be times when there's nothing to be done but wait at a location. This image took half an hour to shoot, as I wanted light to fall precisely on the lone tree toward the upper edge of this field. Mounting my camera on a tripod meant I could stand and watch, and press the remote release at the appropriate time.

Right: One effect of being closer to the equator is how rapidly the sun appears to rise and set compared to temperate zones. This fact means that time is limited if you want to shoot at twilight. Planning is therefore even more critical, so that time isn't wasted.

SEASCAPES

The coastline has a special appeal to the landscape photographer. This is primarily because it's a dynamic environment that changes constantly throughout the day. Shooting seascapes is therefore challenging, but also highly rewarding.

There is no such thing as a typical beach. There are sandy beaches and rocky beaches, beaches covered in shingle, and beaches comprised of broken seashells. Each of these brings its own challenges and rewards.

The first challenge is staying safe. There are numerous hazards on a beach, the biggest being the sea itself. Tide tables are a vital resource when shooting at the coast—not only so you can plan your photography, but also in order to stay safe. You should always take care not to get cut off by incoming tides, so be aware of how tides may affect your passage across or up and down a beach. A less obvious danger is slippery rocks—seaweed covered rocks can be treacherous, particularly when you're weighed down with camera gear.

Photographically, the challenges are equally numerous. Sand, being brighter than a midtone, can fool camera exposure meters into underexposing, meaning that 1- or 2-stops of positive exposure compensation is often necessary. Another challenge is keeping your camera level, which is especially important when the sea is included in your composition—the sea doesn't slope. Using a hotshoe-mounted level will benefit your photography enormously, as will your camera's built-in electronic level (if it has this feature). However, don't just check it once—a tripod can sink in wet sand without you noticing, especially if you're shooting with water lapping around its legs.

Above: Shooting tidal water running around rocks requires careful timing. It's easier to time a shot as the waves retreat, rather than as they advance.

Right: Planning for this early-morning shot involved working out when and where the sun would rise in relation to the beach; whether the tide would be high or low; and then checking the night before what the weather would be doing!

WATER & MOVEMENT

Water at the coast behaves more dynamically than water flowing along a river or stream—it washes backward and forward, with a force that changes depending on the character of the tides. Waves involve movement, which means that you need to think carefully about the shutter speed you use. Do you want the movement of the waves "frozen" or blurred? If blurred, then how blurred? Waves have an interesting texture and shape, which can be lost if the shutter speed is especially long, but this is entirely an aesthetic choice, with no right or wrong answer. Use the grid at the right to help you decide which effect you would like to create.

Below: Lengthy shutter speeds will smooth out even quite turbulent water. This image required a 4-minute exposure. As a result, the violent, stormy waves that soaked me and my camera have been smoothed out completely, providing the image with a calmness that is entirely at odds with the reality at the time of shooting!

SUGGESTED SHUTTER SPEED

Result	Shutter speed
Wave detail frozen	1/125 sec. (or faster)
Blur with texture retained	1/4 sec.
Blur with less obvious texture	1 sec.
Heavy blurring	15 sec.
"Misty," ethereal effect	1 min. (or longer)

Above: It's a rule of physics that when it comes to light, the angle of reflection equals the angle of incidence. Practically, this means that you're more likely to see interesting reflections on wet rocks and rock pools when the sun is lower in the sky.

TIDES

Aim: Take a series of images at the same coastal location at both high and low tide.

Learning objective: To develop an understanding of how the tides alter the landscape.

Equipment checklist:
• Camera and lenses
• Tripod
• Filters (optional)

Brief: Tides need to be taken account of when planning a coastal shoot. For this project, plan two photography sessions at a coastal location. The first session should take place at high tide, the second at low tide, either on the same day or within a day or two at most.

Shoot five images during the first session, from a variety of different positions on the beach. Try to make each composition different so that you have five unique

Above: Low tide often leaves behind pools of water, either in rocky dips or on a beach. These pools make interesting subjects in their own right or as potential foreground interest.

views of the beach. Note where you've shot from on the beach and the focal length used for each shot.

At the opposite tide, replicate the five shots from the first session, shooting from the same places on the beach (or as close as possible if they are no longer accessible) and using the same focal lengths so that you have five pairs of shots with similar compositions.

When planning the sessions, use resources such as websites or a tidal information app for your Smartphone or tablet computer. Maps often show the extent of high and low tides, which will be useful when it comes to visualizing the extent of the beach that will be visible during both of your shooting sessions.

Right: Shooting at sunrise (or sunset) at the coast means juggling four variables: the tide, the time the sun rises or sets, the direction the sun rises or sets, and the weather. This can make it a more complex affair than shooting landscapes!

TIPS

• Look for details on the beach at low tide that aren't visible at high tide.

• The most dramatic waves will be experienced as high tide approaches.

• Salt water will corrode your tripod if you get it wet, so wash it with fresh water when you return home.

• The action of the tides benefits seascape photography because it cleans a beach of distractions such as footprints.

• At low tide, and if the beach is sandy, take care not to walk across sand that could be part of a potential picture. Walk along the margins of a beach—either near the top of the beach or along the water's edge—to find your spot.

ANALYSIS

When you return from your coastal excursion(s), download your images to your computer. If you chose to shoot on two separate occasions you will need to wait until you have the results from both sessions (high and low tide) before you can analyze your pictures.

Above: Low tide reveals details that are hidden at high tide.

1 Study the shots from both sessions, either as prints or on your computer screen. Pay particular attention to the changes that high and low tide make to a beach; the way that different details are made visible; and the character of the sea itself.

2 Arrange your photos in order of preference. Is there a mix between the two sessions or do you prefer one session's photos over the other? If it's the latter, why do you feel this way?

3 Less of the beach is revealed at high tide—did this make it easy or hard to find or replicate your five shots? High tide is generally more dramatic than low tide, but there is less room to maneuver.

4 On the following pages are other factors that can affect tides—the extent of low or high tide due to the influence of the sun or moon, and the way in which the weather can affect waves. Repeat the project taking this information into account, choosing a day when the low and high tide times are different. Compare and summarize the results between the four sessions.

Right: Beaches and coastal areas are never the same twice, making them rewarding locations to return to frequently.

REFINE YOUR TECHNIQUE

It is not only the tides that affect seascapes—the weather also plays a pivotal role. If you find a location you like, consider revisiting it in different conditions to see what difference that makes to your photographs.

- Stormy weather at the coast will cause the highest, most dramatic waves. These conditions are very photogenic and you'll often have the beach to yourself, but more vigilance is needed, as you don't want you or your equipment to be swept out to sea.

- Tides are chiefly caused by a combination of the moon's gravitational pull and the earth's rotation. When the moon is directly overhead the coastline below will experience high tide. Slightly counterintuitively, a coastline exactly 180° around the planet will see high tide at the same time, while coastlines at 90° to the moon's position will experience their low tide. As the moon orbits around the earth it pulls the seas along, altering the tides as it does so. Due to the way the earth rotates as the moon orbits, a coastline will see a high tide approximately every 12 hours and 25 minutes.

- To complicate matters, the sun also has an influence on the tides. A few days after a new moon (when the moon is between the earth and the sun) a coastline will experience its highest high tide and then, six hours later, its lowest low tide of the month (this phenomenon is known as a spring tide, even though it doesn't just occur in spring). When the moon is half full (at first or third quarter) high tide will be lower than average and low tide will be higher than average. These factors mean that careful planning is necessary when photographing a coastline. The Internet is a good source of information in this regard.

Above: Keep your lens (and any filters) free from sea spray—it doesn't take much to mar an image. Keep a few lint-free lens cloths handy to wipe the lens as and when necessary.

Above: The sea gradually erodes the geological features of a coastline. This makes shooting a particular stretch of the coastline over a long period of time an interesting project.

WATER

There's something very compelling about water as a subject, and it has many different visual qualities depending on whether it's flowing or still.

LAKES

The still surface of a lake will be highly reflective (assuming it's not covered in vegetation), which makes lakes perfect for shooting bilaterally symmetrical compositions—the key is to find an interesting subject.

An empty blue or overcast sky reflected in a lake won't be that visually stimulating and will produce a slightly dull photo. However, a strong sunrise or sunset reflected on a lake will add vibrant color and interesting shapes to the water's surface.

Strangely, it is often better not to have direct light on the lake itself, as this can cause problems with glare and contrast. Instead, look for a strong, colorful, well-lit subject reflected in a shaded lake. If the reflection appears too dark, balance the exposure with an ND graduated filter. However, don't be tempted to use too dense a filter—a reflection should always be darker than the original subject.

The surface of the lake has to be perfectly still in order to be reflective—any disturbance caused by wind will ruin the effect. You could use a longer shutter speed, which would "smooth" out the surface, but this will not restore the reflectivity (although the resulting effect can be pleasantly abstract). Lakes tend to be more still first thing in the morning, rather than the afternoon.

Below: Lakes—like the sea—should always be perfectly horizontal. For this shot I used a spirit level fitted to the camera's flash hotshoe to check that everything was level before shooting.

Right: Although color will be reflected in the surface of flowing or wind-blown water, recognizable form in the reflection will be lost.

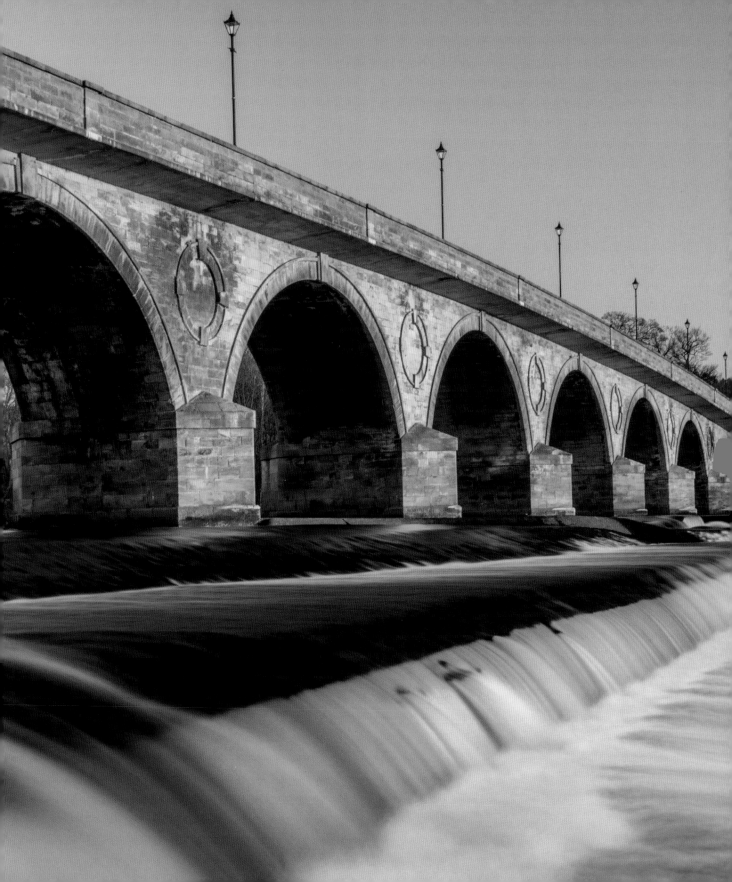

RIVERS

The character of a river will be determined by its size. Rivers often begin high in hilly country, sometimes as several fast-flowing streams that gradually meet to form the main river further on. Waterfalls, whether large or small, are more common at this stage. Rivers that flow into the sea then generally broaden and become slower and deeper as they approach their end.

The shutter speeds you use will depend on the speed of the river during these various states and the effect you want to create. The early stage of a river is ideal for using fast shutter speeds to capture the effect of droplets of water bouncing over rocks, while slower shutter speeds will create a more abstract effect.

Rivers aren't just about water, though. Rivers support life and there are many details, such as reeds and flowers growing along the riverbank that are equally photogenic. Get down low to make the most of such details, but be careful not to fall into the river—riverbanks can be slippery, especially after rain. Towns and cities are often found along the course of rivers, and at dusk, with their lights reflecting in the river, they are particularly attractive.

WATERFALLS

Waterfalls come in all shapes and sizes, from a drop of a few inches to breathtaking torrents, such as the Niagara Falls. Creating a sense of the scale and power of a large waterfall is oddly difficult, as they can seem drastically diminished when viewed in a photograph. One way to overcome this is to include other elements in the composition that help to convey scale—tiny figures of people dwarfed by a large waterfall is one way, or you could use other features, such as trees or buildings. Using rocks as a scale reference is usually less successful, as anyone who views your image won't know how large the rock is unless they were with you at the time.

There's often a fine balance to be struck when photographing waterfalls. Sometimes they can be so full and fast flowing that they appear as a solid white mass when photographed, but at the same time you want some water flowing through! As a general rule, you should avoid shooting waterfalls after prolonged periods of rain or drought (note that waterfalls can also be particularly full with snow melt after a thaw).

As with the sea, there's no right or wrong answer to the shutter speed you use, although very slow shutter speeds can produce disappointing results, as any sense of texture or detail in the waterfall will be easily lost.

Left: For this shot I used a polarizing filter, which reduced the glare on the water's surface, allowing me to see the details of the riverbed underneath.

Left: Longer shutter speeds will blur any detail in the water of the waterfall. This makes it ideal as a simplified backdrop to any interesting details you may find close by. Be careful though—air currents caused by the waterfall can cause delicate subjects to move.

FLOWING WATER

Aim: To take a series of at least six images of moving water, using different exposure times.

Learning objective: To explore how the appearance of moving water can be controlled using shutter speed.

Equipment checklist:
- Camera and zoom lens (or prime lenses) covering wide-angle to telephoto focal lengths
- Tripod and cable release
- ND filters
- Polarizing filter (optional)
- Waterproof clothing and boots

Brief: Compose a shot of a waterfall or flowing river, mounting your camera on a tripod. Focus manually at a specific point in the waterfall or river and don't change the focus point as you shoot the sequence. Set your camera to Shutter Priority (S or Tv) and use a fixed ISO (ideally ISO 100–200 for quality).

TIPS

- Shoot on an overcast day. Not only will this allow you to use slower shutter speeds (as the light levels will be lower than on a sunny day), but the contrast will be more manageable as well.

- Use a polarizing filter to remove or reduce glare from the surface of the water. This can also help to reduce contrast.

- Using a longer focal length lens will allow you to be more selective about what's included in your image. Details can be just as effective as wide-angle views.

- Including a static element (such as a rock) will help add context to your shot. Without a static element the resulting shots may be too abstract.

- Avoid shooting rivers or waterfalls that are too fast flowing or full. At slower shutter speeds any detail is lost more quickly.

Set a fast shutter speed (1/1000 sec. or 1/500 sec.) and take a shot. If this isn't possible (because it requires you to use a wider aperture than your lens allows), increase the ISO by 1 stop.

Increase the shutter speed by 2 stops (to 1/250 sec. or 1/125 sec.) and take another shot. Repeat the process until you are using a shutter speed of 1 second or more—this will typically involve taking six shots. You may need to use an ND filter to achieve the longer shutter speeds if conditions are bright.

Above: In low light it's relatively easy to achieve a slow shutter speed. The river in this shot was in shadow. Apart from an ND grad filter across the sky, no other filter was needed to achieve the desired shutter speed.

Right: In brighter light you will have to use moderate to heavy filtration to achieve a slow shutter speed.

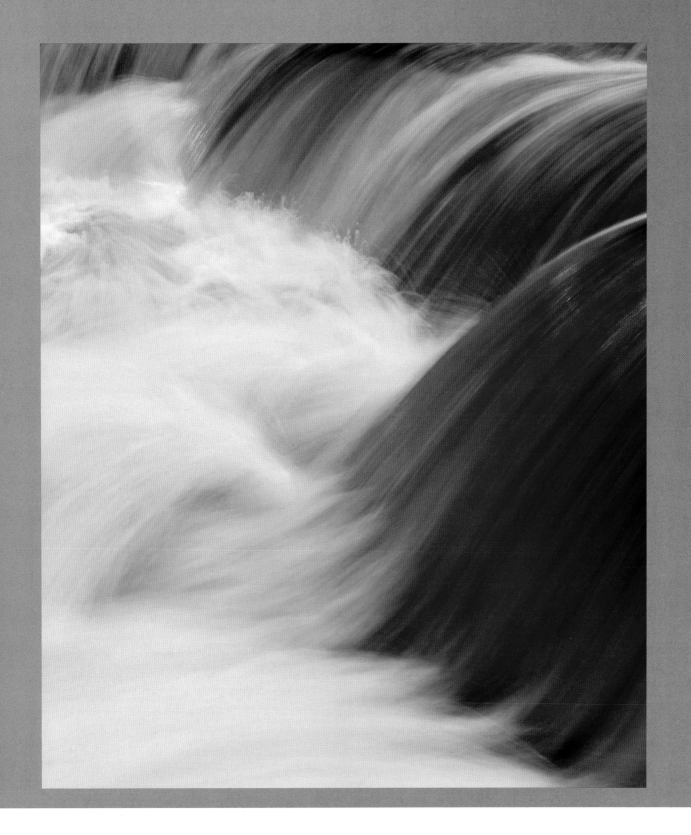

ANALYSIS

The results from this project are best viewed at a large size. Once you have downloaded your pictures from your camera, print them out on Letter- or A4-sized paper, or enlarge them on screen so you can see the differences between the shots most clearly.

1 There's no right or wrong answer to the shutter speed you should use when shooting flowing water. In fact, it's very much personal preference. When you review your images from this project, rank them in order of preference. Don't spend too long worrying about this initial sorting—work quickly and instinctively.

2 Once you've sorted your images, review them again. This time, spend longer looking over them, and try and determine why you prefer one image over another. The reasons could include factors such as the perceived realism of the scene, or whether a particular shutter speed creates an interesting effect.

3 Faster shutter speeds "freeze" movement, and with a fast enough shutter speed you should be able to see individual drops of water (particularly when shooting waterfalls close up). However, we don't see the world this way, so this effect is arguably unrealistic. Think about whether this is important to you. If so, is there a shutter speed used in the sequence that successfully conveys how we normally perceive flowing water?

4 In general, longer shutter speeds simplify the way that moving water is rendered in an image. This can be pushed to the extreme so that

Above: It's a slight visual cliché, but fall leaves on wet rocks add an interesting splash of color to a composition.

water appears unnaturally smooth. Have any of your images exhibited this tendency? If so, think about whether this is an effect you like or whether there's a definite point where the effect is overdone.

5 As you alter the shutter speed in Shutter Priority mode the camera adjusts the aperture. The faster the shutter speed you use, the wider the aperture will need to be in order to maintain the same level of exposure. This will reduce depth of field. Look closely at the image shot with the fastest shutter speed. Has the image been compromised by the reduction in the depth of field?

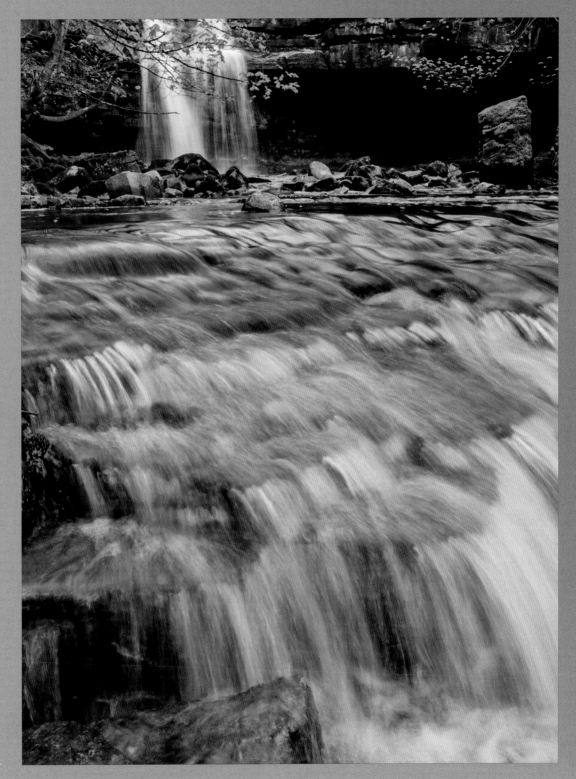

Right: Getting close to a waterfall (either physically or with the use of a telephoto lens) will increase the sense of the speed of the flowing water.

REFINE YOUR TECHNIQUE

Learning about the effects of shutter speed on movement is a core photographic skill, so this is definitely a project that you could—and should—consider repeating.

- The speed at which water is flowing plays an important part in how blurred (or not) it appears in an image: the slower the water flow, the longer the shutter speed needed to create blur. The reverse is also true: the faster the flow, the faster the shutter speed you will need if you want to "freeze" movement. Consider returning to your original location over a period of a few months or even a year. Shoot after rain and after long periods of little rain to see what difference this makes to your images.

- Rivers and waterfalls that are full can be very turbulent. This can lead to foam and detritus covering the surface and surroundings of the river or waterfalls. Foam can be a particular problem as its brightness can easily lead to burnt-out highlights. However, there are creative ways to deal with these problems. Foam swirling through an image can leave interesting trails when long shutter speeds are used. If faced with these problems try to think of imaginative ways to solve them.

Below: Think carefully about image orientation when composing a shot of a waterfall. This waterfall immediately suggested a horizontal composition. Shooting vertically would have lost the sense that it was a wide waterfall, rather than a tall one.

Right: A telephoto lens will allow you to emphasize the detail in a waterfall over its context. Cropping in tightly will also create a less literal, more abstract image.

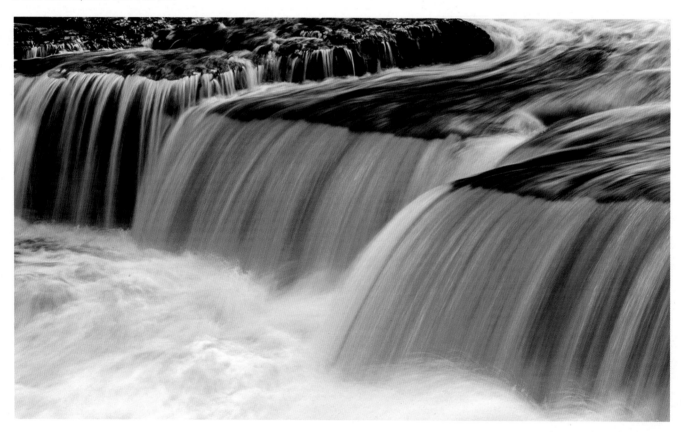

CLOSE-UP

Landscape photography encompasses the small as well as the large, so shooting natural details close-up can be as rewarding as shooting wide-open vistas.

HOW CLOSE?

Most lenses will allow you to focus to within 20 inches (50cm)—the exceptions tend to be telephoto lenses that often have very restricted close focusing capabilities. This is fine for close-up shooting, but not for very close-up ("macro") shots.

If very small details interest you then you'll need to invest in a macro lens. This type of lens allows extremely close focusing, to record details that are hard to see with the naked eye. However, macro lenses are very specialized and expensive for that reason.

A cheaper alternative is to use close-up attachment lenses on your standard camera lens. These are essentially magnifying glasses that extend the close-focusing capability of the lens.

Another solution is to use extension tubes. These are hollow tubes that fit between the camera and the lens, again extending the lens' close-focusing ability. However, cheaper extensions tubes don't have the electronic connections that enable a lens to autofocus or adjust the aperture—extension tubes that do have these connections tend to be significantly more expensive.

Below: Macro lenses allow you to focus on tiny details. They are an expensive option, but fortunately they can usually be used as a standard lens as well.

Right: This image was created with a standard 70–200mm zoom lens set at its minimum focusing distance and maximum aperture.

TECHNIQUE

There's nothing fundamentally different about shooting close-ups compared to the larger landscape, but there are a few things that can trip you up. Depth of field diminishes rapidly the closer the subject is to your camera. This is a big problem when shooting macro subjects, as depth of field can become virtually non-existent, even when the lens' aperture is closed down to its minimum setting.

Closing the aperture down brings its own problems, though. Unless you increase the ISO, you will need to use a relatively long shutter speed, which means that your subject will need to be very still—tricky if it's a delicate flower that's easily blown in a breeze! Keeping your subject sheltered—either with your body or with a large piece of card or reflector—will help.

Longer shutter speeds also require the use of a tripod, although this should really be considered a necessity for any close-up photography, regardless of the exposure time. This is because any camera movement during the exposure is magnified, so close-up work is prone to suffering from camera shake.

TIP

- Do not use your camera's built-in flash when shooting close-ups, as the camera lens may cast a shadow on your subject.

Above: Although a limited depth of field may seem like a problem, it can sometimes be beneficial. The background in this shot was a mess of distracting details, but using a large aperture and focusing exactly on the lichen meant that any background distractions were rendered out of focus and so became less obvious.

LIGHTING

There is no such thing as "bad" light when shooting close-ups, but you should shoot in lighting that is most sympathetic to your subject. For delicate subjects such as flowers, soft, low-contrast lighting is generally preferable, which means shooting in either overcast conditions or when the subject is in shade.

If your subject is small or accessible this can be achieved artificially by using a piece of card or a reflector. The latter are sold commercially and many are designed to fold up, making it easier to pack into a camera bag. Reflectors—as the name suggests—are principally used to reflect ("bounce") light back into the shadow areas of your subject.

Below: Backlighting works well with translucent subjects such as flowers. When shooting into the light use a lens hood to prevent flare.

PATTERNS

Aim: Take a series of close-up images, where "pattern" is the primary focus.

Learning objective: To develop an ability to look closely at the world around you for small, often overlooked details.

Equipment checklist:
• Camera and lenses
• Tripod

Brief: Shooting close-ups allows you to be creative with shape and form—arguably more so than the larger landscape. For this project shoot one or more images based on each of the following themes: bilateral symmetry, spirals, circles, and polygons (shapes such as squares or hexagons).

Think carefully about what aspects of the natural world will be most likely to exhibit which of the themes. Be as literal or as abstract with your interpretations as you like.

TIPS

• Organic subjects will be less likely to feature polygonal shapes than artificial (man-made) subjects.

• The shapes you're looking for don't need to be perfect—circular subjects could be egg-shaped for instance.

• Select your aperture carefully. Consider using wider apertures to simplify your images, but be sure to focus precisely as depth of field will be limited.

• Longer focal length lenses will enable you to isolate your subjects more easily.

• Think about what type of lighting will help define the shape of your subject most readily.

Shoot this project using Aperture Priority mode. If your subject is three-dimensional (and you want everything sharp through the picture) you will need to use a small aperture. You can check whether everything is in focus by using your camera's depth-of-field preview if it has one. If you want to isolate your subject from its background use a large aperture. Focus precisely on your subject using single shot AF or focus manually.

Above: This close-up scene was very three-dimensional. I wanted foreground-to-background sharpness, so had to use f/22—the smallest aperture on the lens I was using.

Right: As ferns unfurl they create interesting curves and spirals. For this shot I used a 100mm lens at f/4.5 to minimize depth of field. This blurred the background, allowing the natural shape of the fern to stand out against a simplified field of color.

ANALYSIS

As with previous projects, you can either view your images on screen or print them out to compare your results. Printing is often a better option, as it allows you to shuffle the order of your images more easily, as well as viewing multiple images at the same time.

1 Study your photographs carefully, paying particular attention to how effective the image is at conveying the concept of shape. This will be determined by factors such as how large your subject is within the image space and whether there are any distracting elements in the shot.

2 One way to increase the impact of your images is to crop them sympathetically. Study your images again with this in mind. If any image needs cropping, think about the most effective way to do this. You don't necessarily need to use the original aspect ratio of the image; cropping to a square format can work well with round or spiral-shaped subjects.

3 Ask yourself whether the lens you used was the correct choice for your subject and composition. Generally, the longer the lens, the flatter the perspective (because you would need to step further back from your subject). It will also make it easier to exclude unwanted details from your shots.

4 Wide-angle lenses aren't ideal for an abstract approach, as you will need to get very close to your subject to make sure it is a reasonable size in the frame. However, wide-angle lenses are excellent if you want to show your subject in its surroundings.

Above: A short telephoto lens was used for this shot so I could exclude distracting details and tighten the composition.

Above: This shot was cropped to enhance the repetitive pattern of the leaf. At the time of shooting I hadn't noticed a flaw in the leaf, which detracted from the composition.

Above: The use of a wide aperture helped to throw the background of this image out of focus. However, because depth of field was limited I had to focus precisely on the flower head that I wanted to be pin-sharp.

REFINE YOUR TECHNIQUE

Perhaps the greatest challenge you will face with your close-up photography is the limited depth of field, which makes accurate focusing essential. However, there are ways that you can help yourself succeed:

• As depth of field is so restricted when shooting close-ups (and more so when shooting macro images) you will need to focus accurately. This means deciding which part of your subject should be critically sharp and focusing there. Accurate focusing is more critical the more three-dimensional your subject.

• Shooting close-ups in the landscape often means working close to the ground. Some tripods allow you to remove the center column and refit it upside down. This will allow you to position your camera extremely close to the ground, but the obvious drawback is that your camera will be upside down. This is easy enough to deal with if the LCD of your camera can be swung out and positioned freely, but it requires more physical dexterity if you need to look through the viewfinder.

• Accurate focusing is generally easier using Live View, as you can usually magnify the image to check focus. However, you will need to have your camera fitted to a tripod to prevent it moving—this will happen all too easily when handholding your camera, making it virtually impossible to guarantee your composition is as intended.

Above: Out-of-focus highlights help to add interest to a shot. The white and yellow patches behind this dandelion are other flowers in the background.

Left: I couldn't get quite parallel to this rock face when shooting a close-up. As a result I had to use an aperture of f/13 to ensure that the image was sharp from corner to corner.

Right: Beaches are a rich source of interesting detail. However, these details are often ephemeral such as this frond of seaweed left on a beach as the tide retreated.

SHOOTING AT NIGHT

There's no reason to stop shooting just because the sun has set. Landscape photography at night is an increasingly popular subject, although there are several challenges to be understood and overcome.

LOW LIGHT

The one big difference between shooting a landscape during the day and shooting it at night is that it's going to be dark! This means exposure times are going to be lengthy or the ISO will need to be increased. You may also need to set your lens at its maximum aperture, but either way, you will definitely need to use a tripod.

There is so little light at night that the shutter speed often needs to be longer than the (usual) maximum of 30 seconds offered by most cameras. To work around this limitation you will need to use your camera's Bulb mode. This is usually either on the camera's mode dial (shown as B) or is found after 30" when setting the shutter speed using Manual exposure mode. When the camera is set to Bulb the shutter will stay open for as long as the shutter-release button is held down.

Below: Away from civilization, there's very little light on the landscape once the sun sets, except for the moon, stars, and any illumination you bring yourself—in this case an off-camera flash to illuminate the lifebelt.

Rather than hold the shutter-release button down with your finger (which would almost certainly result in camera shake) most remote releases allow you lock the shutter open and then unlock it again when required. Some cameras also have a T mode that allows you to press the shutter-release button once to fire the shutter and then again to close it.

The main problem with long exposures on digital cameras is noise. Sensors generate heat when they're active and heat can corrupt image data. To counter this, cameras have a long-exposure noise-reduction option, but the noise-reduction process takes as long to work as the original exposure (so a 1-minute exposure will effectively take 2 minutes). Often, you can't continue to shoot during the noise-reduction process.

The intensity of long-exposure noise varies between camera models, so it is worth turning the function off to see what difference it makes. If your camera doesn't suffer too badly from noise, leave noise reduction switched off, as this will save battery power and reduce the risk that your camera will stop working halfway through an exposure.

Right: The maximum shutter speed on most cameras is 30 seconds. If you need to use a longer exposure then Bulb mode will be necessary.